PLATE COLLECTING

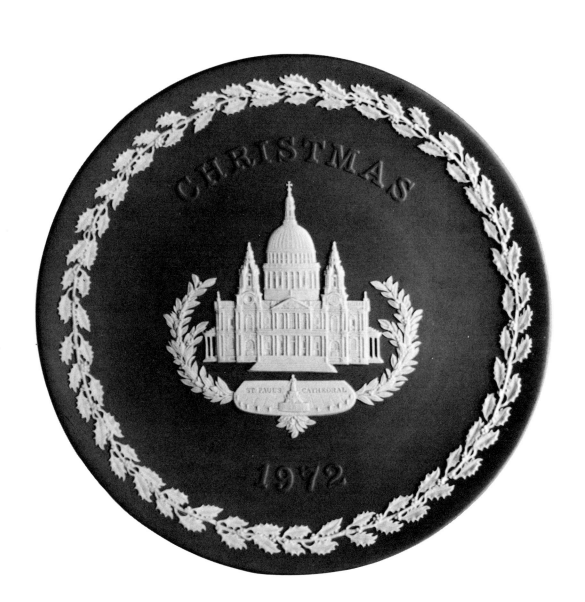

PLATE COLLECTING

By

ELEANOR CLARK

CITADEL PRESS SECAUCUS, NEW JERSEY

First edition
Copyright © 1976 by Eleanor Clark
All rights reserved
Published by Citadel Press
A division of Lyle Stuart, Inc.
120 Enterprise Ave., Secaucus, N.J. 07094
In Canada: George J. McLeod Limited
73 Bathurst St., Toronto, Ont.
Manufactured in the United States of America by
The Murray Printing Co., Forge Village, Mass.
Designed by A. Christopher Simon

LIBRARY OF CONGRESS CATALOGING IN PUBLICATION DATA

Clark, Eleanor.
 Plate collecting.

 Includes index.
 1. Plates (Tableware)—Collectors and collecting.
I. Title.
NK8596.C55 730 76-26098
ISBN 0-8065-0478-1

TO MY HUSBAND, PATRICK,
without whom
nothing I have accomplished in the past eight years
would have been possible.

ACKNOWLEDGMENTS

My grateful appreciation to all of those who helped me in gathering material for this book. All the companies represented in the book were unfailingly cooperative and most enthusiastic about the project. Special thanks to Keith Mervis, Reese Palley, Ruth Wolf, David Schreiber, David Haviland, Allan J. Wilson and Arthur Smith. Lastly, thanks to Joseph Morella, who believed in the book from the beginning. E.C.

TABLE OF CONTENTS

PLATE COLLECTING

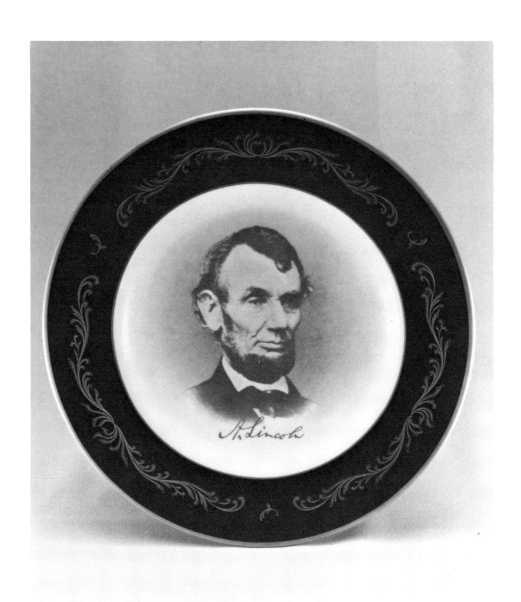

Lincoln plate, a 1973 edition in the Pickard presidential series.

A HISTORY OF
PLATE COLLECTING

Like almost everything else, collecting is heavily influenced by economic conditions. Historically, collecting has been a luxury only the very rich could afford. Obviously, the beautiful collections of sculpture, paintings, antique furniture and other works of art found in mansions, museums and castles throughout the world could only have been amassed by those with ample financial resources. But even on a vastly smaller scale, the leisure time required to pursue a hobby of collecting stamps, books, or whatever, was unavailable to the majority of the population. There is little incentive or desire to collect even worthless objects when the bulk of one's time must be devoted to making a living.

However, the prosperity of the last thirty years has created conditions favorable to the growth of collecting. The abundance of free time and the increase in discretionary income have been the major factors contributing to the fantastic surge of interest in collectibles. The art and antique markets were the first to feel the impact. The overwhelming demand and the dwindling supply caused the prices to soar. The emerging middle class found that many of the traditional collectibles had become too scarce and/ or too expensive. Other objects were needed to meet the demand. Collector plates became one of these objects.

There has been much speculation about the motivations of plate collectors. As might be expected the reasons vary. For many, the plates have

sentimental value. Children or grandchildren started the collection and continued it through the years. Others find a great deal of aesthetic enjoyment from the plates. Their selections are based on personal tastes, and the beauty of the plate is paramount. Many collections were begun quite inadvertently. People with a known fondness for paintings and sculptures depicting particular themes, wildlife for example, were often the recipients of a plate featuring their favorite subject. For others, plate collecting represents a vehicle for investment. Their choices are made on a more objective basis. The status of owning a "limited edition" object influenced others to begin their collections. The idea of relative exclusivity was the major motivation. Many of the most enthusiastic plate collectors admit to the "thrill of the chase." They experience a sense of triumph when they have located a plate considered long out of circulation. The composition of the plate porcelain, glass, silver sometimes is the determining factor for many plate collectors. Coin collectors became avid collectors after the mints entered the market. They collected the sterling silver plates exclusively. Ardent admirers of Edward Marshall Boehm, Dorothy Doughty, Norman Rockwell, and various other artists bought only those plates which offered works by their favorite artist.

Though the practice of collecting plates is a relatively recent phenomenon, the decorative plate has long been held as an object worthy of artistic value. Then as now the plates sometimes depict scenes from history, literature or current affairs.

One of the oldest plates is called "The Paris Plate," so named because its theme was based on the Judgment of Paris, an incident which ultimately led to the famous Trojan War. The plate measures 8¼ inches in diameter and is made of thin glass and is painted in reverse colors. The exact location and time of creation has been difficult to determine but it is believed to have occurred between 250 and 350 A.D. in Syria. "The Paris Plate" represents an example of the ornate and splendid decorations common to the luxurious living of the Roman era.

The portraits of Saints Peter and Paul are found on a small plate, 4 inches in diameter, discovered in the 4th century A.D. The technique of placing a thin layer of gold leaf between two pieces of glass was frequently employed for the making of jewelry and the bottoms of bowls and drinking glasses in the third century. Furthermore, stories from mythology, the Old and New Testaments inspired the designs for many of the works of that period.

The artistry of the glass makers grew more sophisticated and between the eighth and eleventh centuries, elaborate plates and bowls were created. A Persian plate made of amethyst glass in the eighth century depicts a king mounted on his horse flanked by a lion, a serpent and two ibexes. The design for the Persian plate is believed to have been inspired by a Sassanian silver dish.

In the thirteenth century, a small nativity plate reflected the religious motif common to medieval art. In the center of the plate is the crib of the Christ Child resting on an altar.

The Venetian love for vivid colors and sumptuous ornamentation is strikingly portrayed in the Venice Plate (1525). The deep blue plate which is nine and seven-eighths inches in diameter is heavily enameled and gilded. The coat of arms of the Medici Pope in the center design is accentuated by swirls of red and green.

The Venetian love for decorative objects led to the production of many plates. The designs were sometimes quite intricate, if somewhat primitive. Floral patterns and simulated lace work can be found on their plates. Others were engraved with a sharp point similar to a diamond. The technique of applying glass threads to plates is called Latticinio and was a Venetian process. They were skilled at trapping tiny air bubbles to form designs. A seventeenth century plate of striking colors featured the scene of a family dancing. Melted rods of glass were used to make the unusual plate.

The history of the plate as an art object or a decorative ornament is obviously a long and varied one. But to the modern plate enthusiast, the plate as a collector's item had its beginning in 1895. That was the year Harold Bing, head of the Danish porcelain manufacturing firm Bing & Grøndahl, decided to issue a commemorative plate for Christmas. The Danish painter F. A. Hallen was selected by Bing to design the first plate. The artist's design depicted the Copenhagen skyline on a winter's night. The notation "Jule Aften 1895" was inscribed on the front of the plate. The plate sold well and so the Christmas Plate became an annual issue for the company.

Bing's idea of a decorative Christmas plate was an innovative one for a commercial enterprise. However, the Christmas plate had been a traditional custom for many years. Its origins are hazy but legend has it that the practice began accidentally. The rich nobles made it a practice to reward their servants at the holidays by giving them platters laden with food and fruit. After the feast, the servants kept the platters and hung them on their walls. Gradually, the platters began to take on a greater significance. The nobility began to compete with each other. The original idea of the holiday bounty grew less significant as the platters themselves became more important. Efforts were made to create unique platters employing varied materials, including wood, metal, and pottery. Some were elaborately carved while others featured painted designs. Eventually the practice of dating the plates became common.

Bing and Grøndahl remained the only company manufacturing Christmas plates until another Danish firm, Royal Copenhagen, introduced its annual Christmas plate in 1908. Several other manufacturers commenced producing the plates. The plates were popular throughout the world but were con-

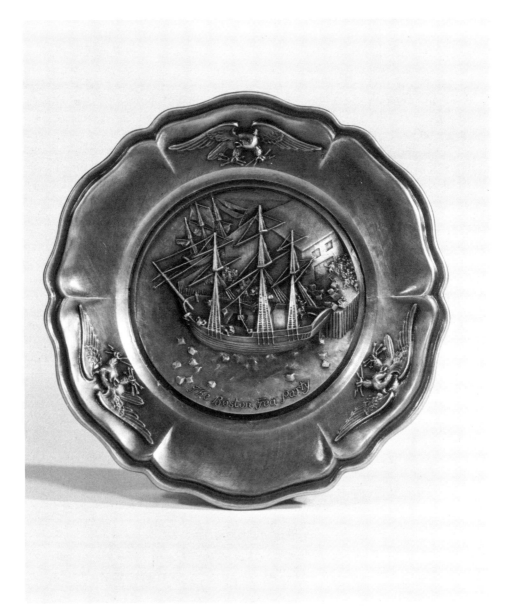

"Boston Tea Party," introduced in 1972 by Royal Worcester's pewter division.

sidered specialty items. For many years no real importance was attached to them.

In America, the Christmas plates went relatively unnoticed in most parts of the country. For many years they were considered sentimental Christmas gifts selling for just a few dollars. But during the years 1945 to 1965, the Danish plates established a foothold in the Midwest of the United States. The plates were exceedingly popular in states such as Iowa, and housewives began to take a real interest in collecting them. These housewives were generally unsophisticated. The Danish plates with their traditional scenes were immensely appealing. Little emphasis was placed on artistic significance or appreciation potential. Gradually the housewives became more organized. Arrangements were made with suppliers, guaranteeing a set number of orders. One housewife would act as the order-taker (much like the Tupperware parties) for her friends. Some of the more ambitious expanded and became sub-wholesalers or jobbers supplying a greater number of people with the plates. However, the entire operation continued to be quite small until approximately 1969. But during the years 1965-1969,

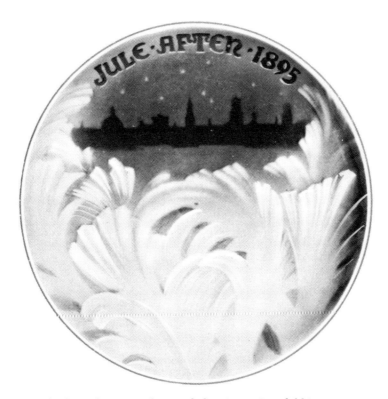

The first Christmas plate made by Bing & Grøndahl in 1895.

the world of collector plates had expanded far beyond the Danish Christmas plates and the Midwestern housewife.

In 1965, the French firm Lalique, famed for its beautiful work in glass, issued an annual plate. Two thousand plates were produced in 1965 with only one thousand available for U.S. distribution. Though retailers paid scant notice, the public responded with enthusiasm. Originally issued at $25.00, the 1965 Lalique plate doubled and then tripled in price within a year. Eventually, the price peaked at $1,000.

Though the 1965 Lalique plate represented a significant milestone in the field of collector plates, it was several years before the manufacturers and retailers recognized the potential market for plates. Between the years 1965-1969, the market remained fairly stable. Bing and Grøndahl, Royal Cophenhagen, Rosenthal and other old line companies continued to produce their Christmas plates. The plates enjoyed a favorable public reception, but none had the impact of the 1965 Lalique plate.

However, in 1969, the aura attached to Christmas plates changed. The first Christmas plate by an English ceramic company was introduced. Wedgwood, the largest producer of domestic earthenware in the world and famed for its jasperware, chose to celebrate the founding of its factory in Etruria in 1769 by issuing its first Christmas Plate. The eight-inch plate was made of the familiar pale blue and white jasper, recognizable throughout the world as Wedgwood. A view of Windsor Castle was depicted on the plate. The design was hand-ornamented in white bas-relief. The plate had a border of holly leaves, also done in white bas-relief, while the inscription "Christmas 1969" was embossed in blue. Though the company refuses to disclose the size of any edition, it is believed that the 1969 edition numbered between five and ten thousand.

However, the company emphasized its belief in the concept of a limited edition by publicizing the destruction of the mold for the 1969 Christmas Plate. The plate was an immediate success and its original issue price of $25.00 more than doubled within a short period of time. Eventually the market price skyrocketed to $200. Today a 1969 Christmas Plate would bring approximately $100.

The Wedgwood Christmas plate changed the market for two major reasons. Firstly, it was a company whose name was recognized throughout the United States. Secondly, it proved that the Christmas plate was not a mere novelty item costing six or seven dollars. The plate could command $25.00 from the public.

Manufacturers and retailers needed no further convincing. There was a huge market for collector plates. The exact size of the market was yet to be determined, but its potential could no longer be ignored. Within a year after the Wedgwood Christmas plate, there were over fifty other plates introduced. The collector plate market had exploded.

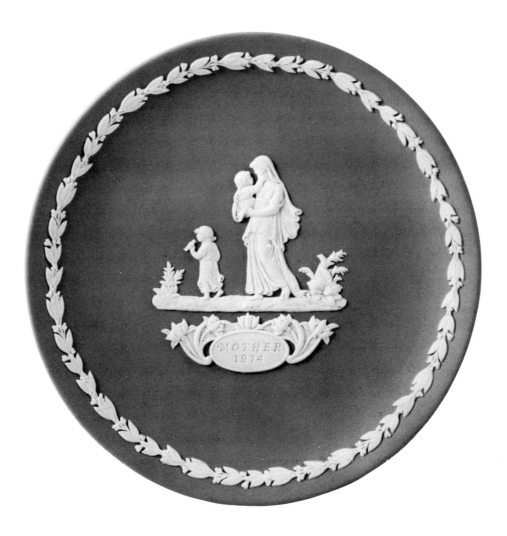

Mother's Day, a 1974 plate by Wedgwood, the fourth in a series.

Undoubtedly one of the biggest factors contributing to the market's surge was Franklin Mint. In 1970, Franklin Mint startled the plate-collecting world by announcing its sterling silver Christmas plate series. The Mint had commissioned Norman Rockwell to design the six plates. Several reasons accounted for the stir created by Franklin Mint's decision. The idea of a sterling silver plate was revolutionary, as almost all plates produced to that time had been porcelain or of similar composition. Secondly, the issue price was $100, an unheard-of sum for the market. Furthermore, Franklin Mint, while a big name in the coin-collecting field, was totally unknown to the plate-collecting market.

When the plate was shown to the retailers, it met with a cool reception. Buyers for prestige department stores and other similar outlets were skeptical. They refused to stock the plate since they were sure it would not sell. However, Keith Mervis of Carole Stupell Ltd., a New York shop, felt otherwise. As he says, "I gambled." Mr. Mervis, who first saw the plate at a trade show, was impressed by the merchandising of Franklin Mint. The company from its inception had always employed the most sophisticated packaging and display designs to sell its other products. The same techniques were used for the Christmas plate. It was given its own booth and a

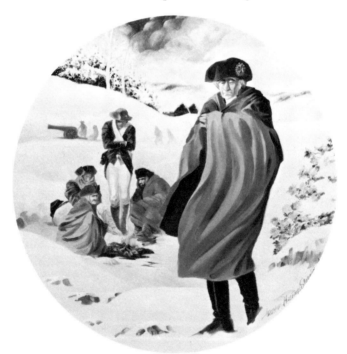

"The Silent Foe at Valley Forge," 1973, the American Historical Plates Limited, is the third of 16 plates produced to commemorate America's Bicentennial.

Porsgrund's 1973 Father's Day plate, the third edition in an
annual series.

simple but dramatic display. The sterling silver plate was placed in front
of a black velvet cloth, which formed an effective backdrop. The purchaser
would also receive an elegant case for the plate.

Mr. Mervis told Franklin Mint's sales representative that he would buy
all the plates available. According to Mr. Mervis, there were several rea-
sons for his confidence. He felt that this particular type of plate had opened
a new market for Christmas plates. He envisioned it as the solution for the
busy executive who needs a unique gift for business friends. In addition,
he felt the Norman Rockwell design would provide a great incentive to
many people who had never considered purchasing collector plates before.
The idea of a plate made of sterling silver made it far more valuable and
prestigious. Coin enthusiasts would appreciate it. People concerned about
the fragile nature of porcelain plates would have no misgivings about the
longevity of the plate. The very sound of "sterling" carried an aura that
porcelain would never attain.

Mr. Mervis's gamble paid off. The Franklin Mint plate was an unbeliev-
able success. Within a year Carole Stupell was advertising that it would
buy the plate back for $450. A store official was quoted as saying that the
shop could resell the plate at $675.

By the fall of 1971, the salesmen for Franklin Mint were encountering no difficulties in booking orders for the second plate in the series. In some cases, they were in the favorable position of refusing orders. From the start, Franklin Mint had an unusual sales distribution outlet at its disposal —its subscription list for the company's other products. These subscribers were given the first opportunity to purchase the plates. After 1970, plates were allocated to dealers on the basis of previous year's order. Obviously, Keith Mervis of Carole Stupell and others who had guessed right in 1970 benefitted from this policy. Consequently, the demand for Franklin Mint's Christmas plate was difficult to fill at the retail level. By the fall of 1971, before the plate was officially issued, the price had risen to $325.

The boom in collector plates continued. By 1972, there were over two hundred different plates on the market (and by 1976 over 1200 were reported to be in existence). There were plates made of porcelain, glass, silver, silver and gold, gold, pewter, and wood. No longer was the market confined to Christmas plates. Bing and Grøndahl, the company who had initiated the concept of a collector plate, introduced the first Mother's Day plate in 1969. Its success prompted other manufacturers to follow suit. There were plates to commemorate Mother's Day, Father's Day, Easter, and Thanksgiving. The designs and themes for the plates became more varied, ornate, and sophisticated as the manufacturers competed for the collector's attention and dollar. Following the lead of Franklin Mint, which had commissioned Norman Rockwell to do their Christmas plates, other producers sought name artists. Lenox, one of the most respected names in American china, selected the works of Edward Marshall Boehm for its plates.

The three generations of America's first family of art, the Wyeths of Pennsylvania, had their works displayed on collector plates. "The Arsenal of Democracy," a work by the late N. C. Wyeth, graced the first plate in George Washington Mint's series "The N. C. Wyeth Americana Series." Georg Jensen selected Andrew Wyeth for its 1972 plate. James Wyeth, the grandson, was commissioned by Franklin Mint for a series of original works. Gorham went back to the Old Masters for its series of plates featuring reproductions of Rembrandt and Gainsborough paintings.

The Edward Marshall Boehm Studio issued "The Bird of Peace Plate" in 1972. It was physically manufactured by Lenox. Its design was inspired by the pair of sculptured swans the studio had made in 1971 and which were ultimately presented to Mao Tse-tung by President Nixon on his historic trip to China.

Historical events such as the landing on the Moon, the Olympic Games, Presidential inaugurations, and the Bicentennial Anniversary of the U.S.A. were favorite themes. The Bicentennial inspired numerous series of plates, including those by Haviland, Royal Worcester, Wedgwood, and American Historical Plates, Ltd.

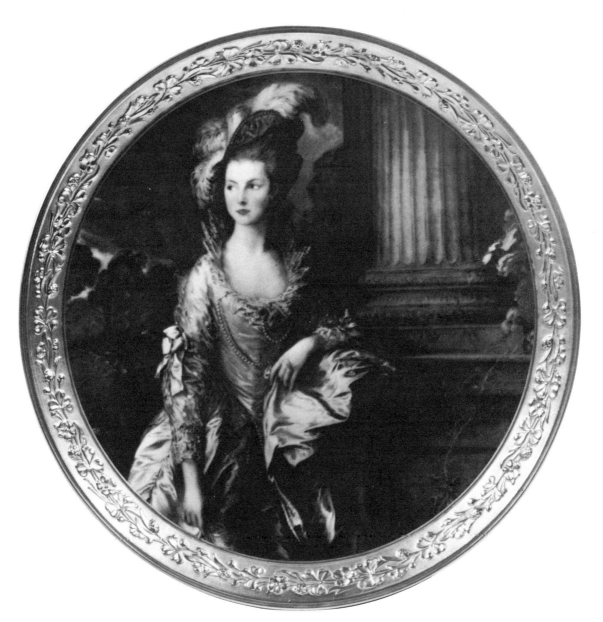

"The Honorable Mrs. Graham by Gainsborough," issued in 1973, was
the third plate in the Gallery of the Masters series by Gorham.

In 1972, American Historical Plates Limited issued "The Turning Point," the first plate in a series of eight to commemorate the United States Bicentennial.

"A New Dawn" was the title of the second plate (1972) in American Historical Plates Limited's Bicentennial Series.

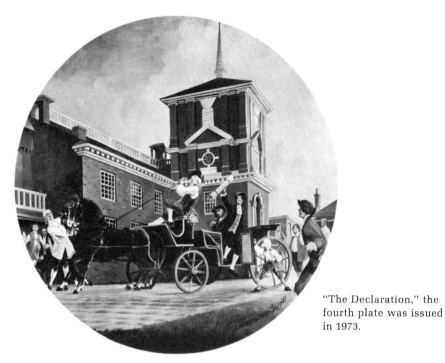

"The Declaration," the fourth plate was issued in 1973.

Arthur Hastings Slogatt, the artist for all the plates in the Bicentennial Series produced by American Historical Plates, chose the *U.S.S. Constitution* as the subject for the fifth plate.

The sixth plate in the series was entitled "The Star Spangled Banner."

Svend Jensen and Wedgwood produced a series of plates based on the fairy tales of Hans Christian Andersen. The cartoon "Peanuts" is recreated on a collector plate.

However, religious themes and works by wildlife artists remain the most popular. Royal Worcester (Dorothy Doughty), Pickard (Lockart), Franklin Mint (Audubon), Lenox (Boehm), Wallace Silversmiths (Ruthnen) are some of the companies which produce plates depicting birds in natural settings.

The public response to Franklin Mint's sterling silver plate spawned a host of imitators. Within a short period of time, the Lincoln Mint, the George Washington Mint, and several others were founded. The George Washington Mint gained the most publicity, since its founder, Reese Palley, was adept in the fields of publicity and public relations. Palley had been tabbed "Merchant to the Rich" for his ability to merchandise expensive gift items like the Boehm porcelains.

The incredible saga of collector plates came under the scrutiny of the media in the early 70's. Numerous newspaper and magazine articles appeared. *The New York Times*, the *Wall Street Journal*, and *Forbes* were

Entitled "Westward Ho,"
the seventh plate portrays
a train of covered
wagons travelling west.

just a few of the big-name publications which ran feature articles on the subject.

Collector plates had become big business. Big department stores had overcome their initial misgivings. David Goldstein, a buyer for B. Altman, a big New York City department store, was quoted as saying, "Christmas plates have made everybody a collector" and estimated that Altman would sell 500 to 700 copies of every plate carried.

Small shops scattered throughout the country which had been doing a modest but steady business in the Danish plates experienced sharp increases. The hefty advertising campaigns underwritten by the manufacturers, the publicity in the media, and word of mouth brought thousands of new customers into the market. New shops sprang up. Many were run by housewives who loved plates and discovered that acting as a dealer would be both fun and profitable. Ruth Wolf, the owner and proprietor of Limited Editions in Freeport, Long Island, represents a good example. Mrs. Wolf started her business almost by accident. She had been purchasing plates for friends who trusted her judgment and ability to obtain a good deal. Within two

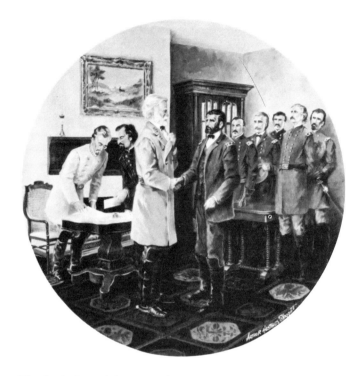

The final plate of the series depicts the scene at Appomattox,
and is called "One Nation."

and a half years she had parlayed her hobby into a thriving business. At
present she has a mailing list that covers the entire country, and she is not
averse to making European trips to buy her merchandise. Ironically, a
part of her business is selling Spode and Wedgwood plates to British shops
which are unable to obtain the desired items locally.

The spectacular price increases experienced by the most popular plates
(Lalique 1965, Bing and Grøndahl's Mother's Day 1969, etc.) were duly noted
by the press. This publicity attracted a new type of buyer to the market—
the speculator. He was encouraged by unscrupulous dealers who advertised
instant profits and by the fanfare that greeted each new issue.

Clubs devoted to the hobby of collecting plates were formed throughout
the country. A magazine called, simply, *The Plate Collector* was founded,
and tours to European factories were organized.

To the uninformed there seemed to be no end to the remarkable growth

of collector plates. However, by the end of 1971, there were many who were skeptical of the future. The entire concept of a "limited edition" became a subject of controversy. Critical articles in newspapers and magazines became common. Dire predictions about the market's future became frequent.

By early 1973 it was obvious that the market had softened. Prices tumbled, companies cut back on production, some companies ceased operation (the George Washington Mint, for example, was taken over by the Medallic Art Co.; other mints shut down), dealers experienced declines in business and serious regulatory agencies began investigating the advertising claims for limited editions.

In retrospect, it is obvious that the market could not sustain its dizzying pace. It was inevitable that a slowdown had to occur.

However, it is just as obvious that the market's decline was hastened by abuses within the industry. Manufacturers flooded the market with plates, some of them quite inferior in quality. Dealers inflated prices and engaged in false advertising.

The market was sometimes manipulated by unscrupulous dealers. A group would conspire to inflate the market value of a plate by falsely advertising the price. For example, a plate with an original issue price of $100 would be advertised by one dealer at $125, another at $150 and a third at $175. This type of promotion was intended to mislead the public into thinking that the plate was in great demand and that prices were skyrocketing. Lincoln Mint's "Collie With Her Pups" plate was promoted by some dealers in this fashion.

Sound business practices were ignored in the haste to capitalize on the fantastic profits ballyhooed in the press. Some dealers overstocked, hoping to reap huge profits personally. The success of the 1969 Wedgwood Plate caused many dealers to order far too many copies of the 1970 issue. The glut on the market not only wiped out the profits they had hoped to gain on the extra copies they had ordered for themselves, but the entire issue was hurt. In 1972 Wedgwood reduced the size of its editions to approximately the levels of 1969.

It had been forgotten that the collector's plate market was as unpredictable as any other market governed by the ever-changing tastes and desires of the customer. The delicate balance between supply and demand was upset. The original motivation for collecting plates became lost in the web of speculation and exploitation. Eventually, the ultimate judge, the collector himself, became confused and then disillusioned.

Fortunately, the saga of collector plates has a happy ending. There were enough reputable manufacturers, honest dealers and sincere collectors who refused to compromise their high standards. Their vigilance and their belief

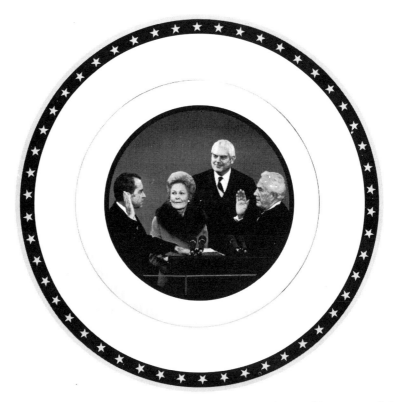

The U.S. Historical Society issued the 1973 Inaugural plate designed by Raymond Geary.

in the market withstood the decline. Furthermore, leaders in the industry took steps to preserve the integrity of the market.

Early in 1973, Mrs. Louise S. Witt, a recognized authority on plates, organized the International Plate Association, which was composed of manufacturers, dealers and collectors.

As stated by Mrs. Witt in the first newsletter published in March, 1973: "Our International Plate Association is to be non-profit with by-laws and constitution. . . . Our primary goal is to see that our fascinating lovable hobby of plate collecting remains among the top collectibles."

The organization planned to discuss and formulate a policy about truthful advertising, speculation in the market, a clarification of the phrase "limited edition" and other related matters.

The controversy over the term "limited edition" played a significant part in the adverse publicity the collector's plate market received. There were so many different interpretations of the term during the heyday of the market that the public became understandably confused.

Reese Palley offers this definition: "An edition of a contemporary prod-

Royale's 1973 Father's Day plate.

The American Bald Eagle is the subject of Royale's 1974 Father's Day plate.

Royale's 1973 Mother's Day plate was designed by Jack Poluszynski, a young Canadian artist.

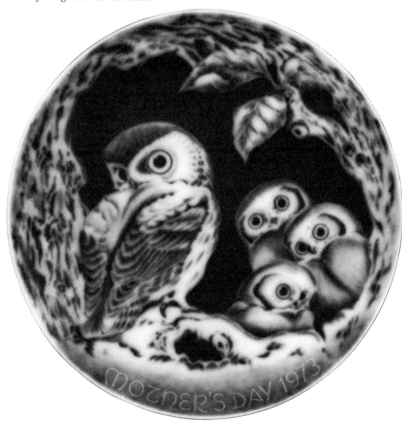

uct, in which the total number of the edition is announced at the time production is commenced.

"This same definition refers to limited issue, restricted issue and restricted edition."

For example, Haviland introduced its Martha Washington Plate with the understanding that only 2,500 plates were to be issued.

Franklin Mint adheres to a completely different interpretation of the term. Peter H. Jungkunst, manager, retail sales, for Franklin Mint, discussed his firm's policies in the second issue of the International Plate Association's newsletter.

"Virtually all plates offered nowadays are advertised as limited editions. But are they? The term 'limited-edition' is a relative one. The true limited-edition is one that falls short of demand," he wrote.

"Most of the companies now offering collector's plates announce a numeric limit to the edition when it is offered. But, such pre-set numbers are arbitrary, they don't have any relation to the actual demand for the

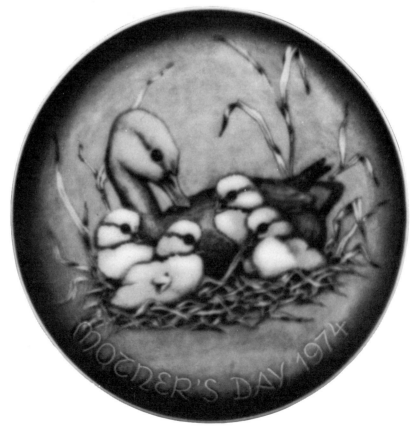

The 1974 Mother's Day plate of Royale featured a mother duck with her ducklings.

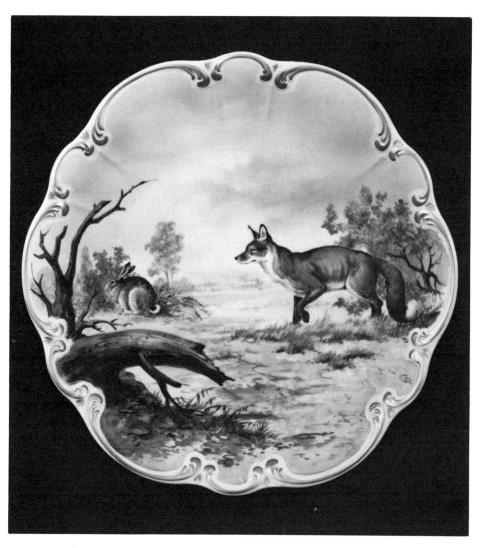

In 1972, Royale introduced its Game Plate Series. "Two Setters Pointing Quail" by the Canadian artist Jack Poluszynski was the first of the twelve in the series.

plate. The result, more often than not, is that these editions are not sold out and 'overhang' the market on dealer's shelves.

"The Franklin Mint goes to great lengths to make sure its editions are truly limited.

"First, it offers its plates and medals for only a short period of time, usually about two weeks, and never accepts orders received after the published deadline. It doesn't pre-set the number of plates it will produce, but makes only enough to fulfill the valid orders it receives.

"Most of the time, the mint receives many orders after the deadline. They are always returned unfilled. This means that demand is exceeding supply right from the outset, a situation of real rarity.

"Second, its plates are offered individually only to its established collectors, not to the general public.

"Third, the mint carefully selects its retail outlets and, this year, is requiring them to register each plate the moment it is sold and only then will it be delivered to the Dealer or directly to the collector. This means that no unsold collector plates will ever be left on sale at retail. It is the mint's belief that any edition can only be truly called limited if it is not available over extended periods of time.

"And, finally, each year the mint published the exact mintage figures for all of its products."

The heady advertising and the wild speculation in the market in the early 70's became a matter of concern to various state regulatory agencies. The New York State Attorney General, Louis Lefkowitz, and the New York City Department of Consumer Affairs investigated the claims made by manufacturers. Both agencies felt that the consumer was being misled by some of the advertising. Too often the ads duped the reader into believing that the edition was so limited that the plates would be hard to find.

The abuses became so widespread that safeguards were needed to protect the public. The New York City Department of Consumer Affairs drafted legislation to combat the problem. The proposed law was published in the City Record in March, 1973.

"In compliance with section 1105 of the New York City Charter and exercising the authority vested in me as Commissioner of Consumer Affairs by Section 2203d—3.0 of Title A of Chapter 64 of the Administrative Code of The City of New York, a regulation regarding deceptive advertising and labeling of alleged "limited edition" products is being adopted, and notice is hereby given of the adoption of the proposed regulation.

"30.1 It shall be a deceptive practice in the sale, lease, or offering for sale or lease of consumer goods for a person (including any business entity) to advertise, claim, or label any product as a 'limited edition,' 'limited printing,' 'limited minting,' 'limited manufacturing,' 'limited crafting,'

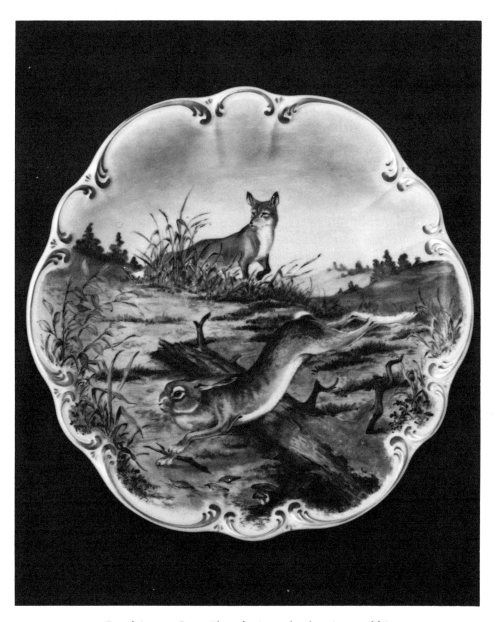

Royale's 1973 Game Plate depicts a fox hunting a rabbit.

Royale Germania Crystal's
1973 Mother's Day plate
was a limited and
numbered edition of
600 pieces.

A mother squirrel with her
young is the scene
depicted in Royale
Germania Crystal
Mother's Day plate
for 1974.

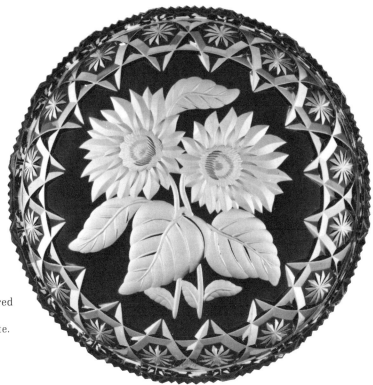

Sunflowers are featured on the 1974 Royale Germania crystal plate.

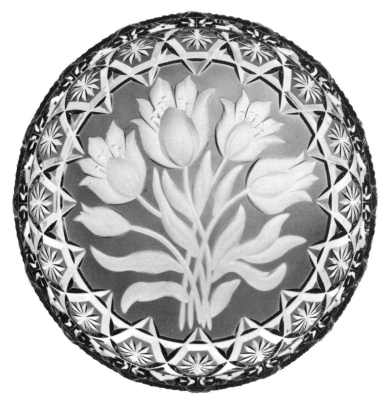

The fourth annual Royale Germania crystal plate (1973) features the tulip as its subject.

'limited production' or any other term which indicates or tends to indicate the limited production of the product if in fact the printing, minting, crafting or production of the product is not limited either to a predetermined maximum quantity or to the actual quantity ordered or subscribed to within a specified and sufficiently short time period.

"30.2 If any product is advertised or otherwise offered for sale or lease as a 'limited edition,' 'limited printing,' etc., such advertisement and other offering media (including but not limited to, such devises as labels, tags and display cards) must include, in clear and conspicuous print, and in close proximity to the words 'limited edition,' 'limited printing,' etc., either the maximum number that were or will be printed, manufactured or crafted, etc., or the time period or date by which the edition will be limited by time.

"30.3 This Regulation shall apply, but is not limited to, books, stamps, coins, glassware, commemorative items, fabrics, furniture, and works of art, including prints.

"30.4 This regulation may be cited as Consumer Protection Law Regulation 30."

EXPLANATION

"The advertising, claiming, or labeling of a product as being a limited edition is done to attract buyers and to enhance the value of the product in question by leading the consumer to believe that he is purchasing something that will not be available in unlimited quantity or for an indefinite period of time. Many individuals and business entities have been deceiving consumers by claiming that only a limited quantity of a given product has been or will be produced, when in fact the printing, manufacturing, etc., of the product is essentially unlimited. This regulation is designed to end this deceptive practice and also to require either the disclosure of the quantity or the limitation that justifies the description 'limited edition,' 'limited printing,' etc."

BESS MYERSON, Commissioner.

The International Plate Association encouraged its members to write to Senator Robert Dole regarding legislation at the federal level. For several years, a bill has been pending in Congress to prohibit the reproduction of antique china, glassware, etc. In 1972 Congress passed a law to protect the stamp and coin collectors. The association favors a similar law prohibiting the reproduction and forgery of plates and figurines.

New York City's regulation No. 30 was brought to the attention of Mr. Dole. Federal legislation patterned after New York City's is supported by the association.

Under the auspices of Reco International Corp, King's Porcelain Factory of Italy
introduced its Flowers of America series in 1973. The first plate
featured the pink carnation.

American Beauty Red Rose is the subject of the 1974 edition of the Flowers of
America Series by King's Porcelain.

King's Porcelain introduced its Christmas plate in 1973. Designed by the Italian artist Merli Bruno, the plate depicts the Nativity scene.

In 1974, King's Porcelain
issued "The Dancing
Boy," its 1974 Mother's
Day plate.

Members of the association's Legislative Committee have appeared before
the congressional committee responsible for the legislation.

Though New York's regulation was hailed as a landmark, it did not
completely quell the questions surrounding the meaning of the term "lim-
ited edition." Many felt that the term was still too ambiguous, that more
precise terms had to be adopted. Anne Scott in her Limited Editions Report
suggested that new terms be adopted. They are:

VERY RARE—describes an edition limited to 50 items or less.

CONNOISSEUR—describes an edition limited in number from 51 to
1,000.

"Girl Dancing for her
Mother" is the title of
King's Porcelain's
Mother's Day plate
in 1973.

PRIME—describes an edition limited in number from 1,001 to 5,000.

COLLECTORS—describes an edition limited to quantities of 5,000 or more.

The attempts to regulate the production of limited editions demonstrate the unique position "contemporary collectibles" occupy in the collecting world. The sincere plate collector buys a plate because he wants to own it. He is either enraptured by the beauty of its design or fascinated by the workmanship, etc.

He is not concerned about its investment potential or the size of the edition. Historically, the plate collector has had little in common with the

stamp collector, the coin collector or the antique collector. These other collectors are understandably concerned about rarity, appraisal value, certification, etc. However, the differences between the two types of collectors is quite simple.

The market for antiques, stamps and coins (before Franklin Mint) is a total reflection of supply and demand. The inability to obtain a particular antique writing desk may be caused by several factors. Maybe only one hundred were made and through the years perhaps fifty were destroyed. Twenty of the remaining fifty are in museums and of the thirty left, only four can be located. This "natural" scarcity creates a demand.

"Scarcity by fiat" for some of the plates is an artificial and contrived means to create a demand. Of course, not all manufacturers of contemporary plates can be categorized in this manner.

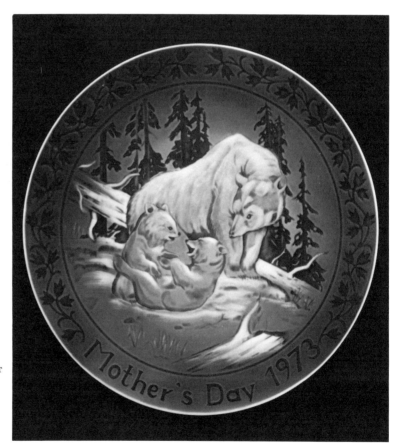

Marmot's Mother's Day plate for 1973 shows a mother bear watching her cubs at play.

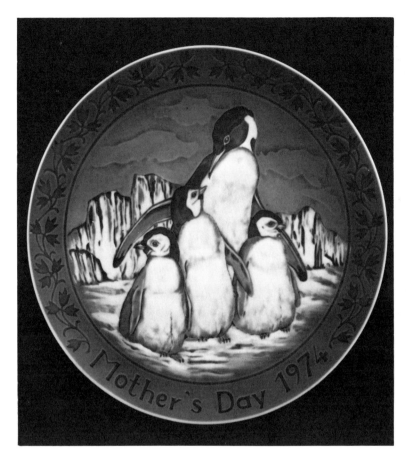

Marmot continued its animal theme in its 1974 Mother's Day plate, which featured a penguin family.

Obviously, the more complex the design, the more skill and time required for production. Consequently, the edition thus becomes self-limiting.

By the latter part of 1973, the plate market had been abandoned by the speculators and the quick buck artists. The forecasters of doom had been proven wrong.

The true plate collector remained steadfast and the market stabilized. The future for plate collecting is bright. Attendance at shows exhibiting plate collections has never been greater, the International Plate Association continues to enlist new members, dealers report strong business and the credibility of the market has been strengthened considerably.

Plate collecting was not a fad. It is a lasting and totally satisfying pursuit for hundreds of thousands of people.

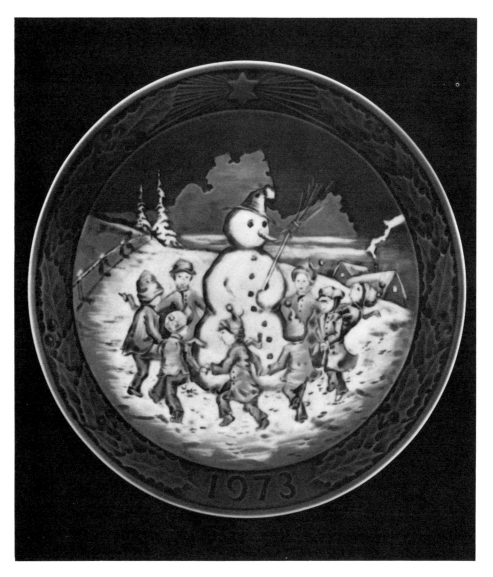

Children dancing around a snowman is the subject of Marmot's 1973 Christmas plate.

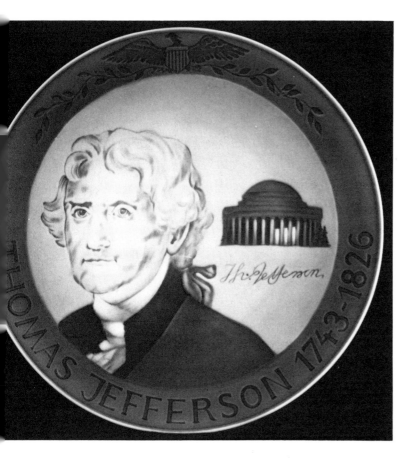

Thomas Jefferson was the
subject of the second
plate in Marmot's
presidential series.

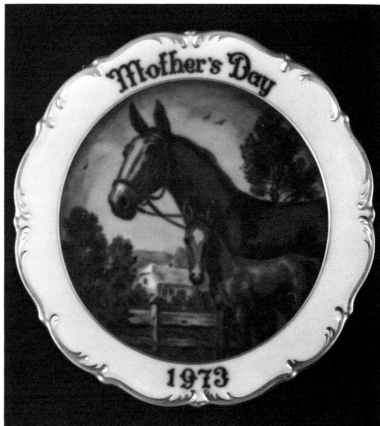

Dresden's 1973 Mother's
Day plate featured a horse
with her colt.

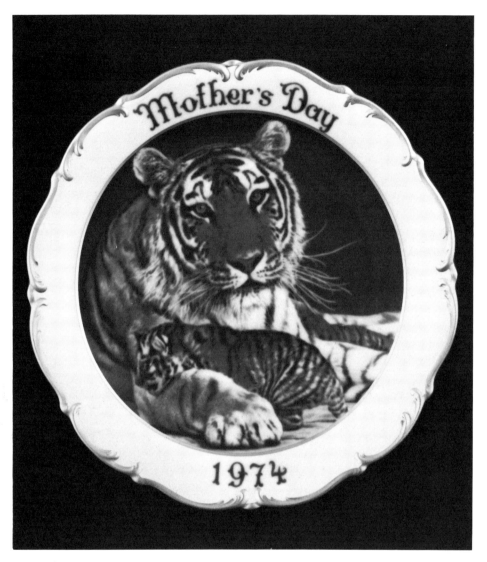

The mother tiger holding her cub is the subject of Dresden's 1974 Mother's Day plate.

"Collie and Her Pups" issued by Lincoln Mint in 1972.

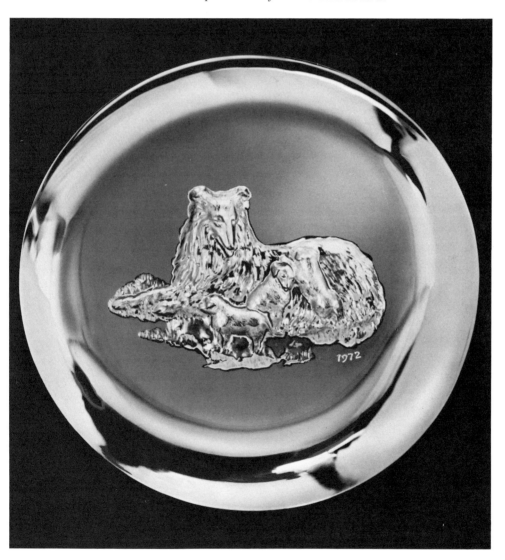

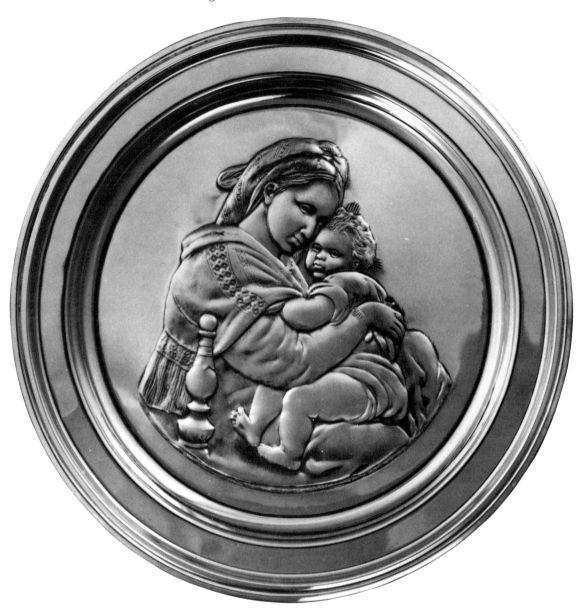

A reproduction of "Madonna Della Seggrola" by Raphael was issued in sterling silver and 18k gold by Lincoln Mint.

"Easter Christ" was created for the Lincoln Mint by Salvador Dali.

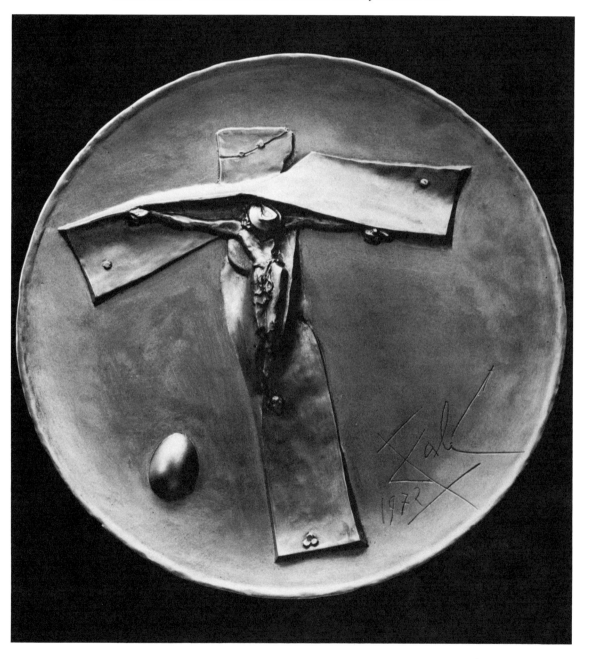

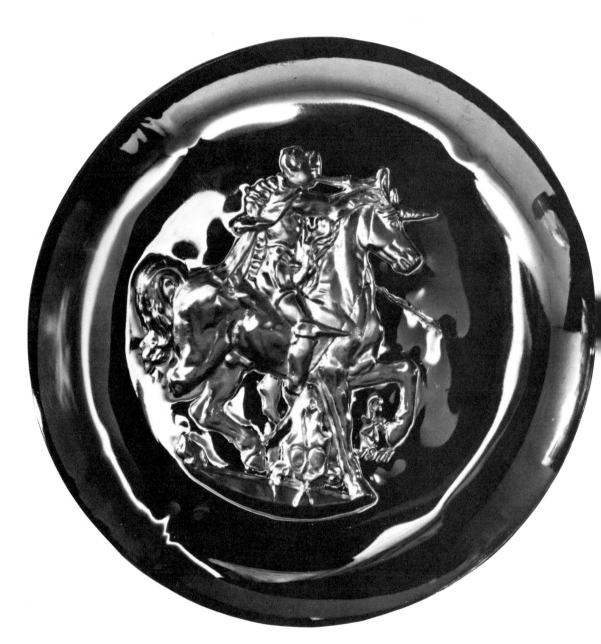

Salvador Dali created the design for the 1971 plate by Lincoln Mint.

A HISTORY
OF
THE COMPANIES

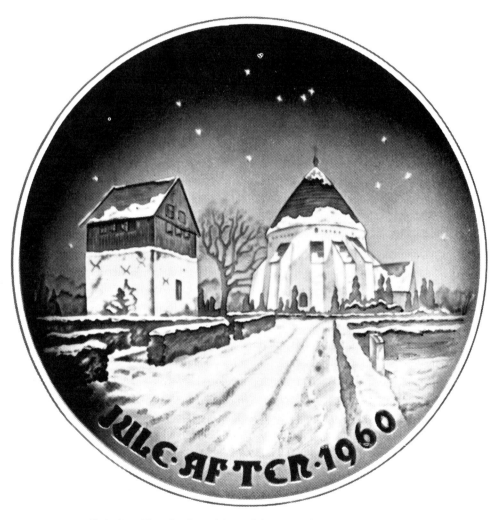

JULE·AFTEN·1960

Osterlars Church, the subject of the 1960 Christmas plate, is
located on the island of Bornholm and is one of the seven
round Churches of Denmark.

BING AND GRØNDAHL

Bing and Grøndahl, the company which produced the first Christmas Plate, was founded in 1853. A dispute about an artistic concept inspired the company's beginnings. Frederick Velhelm Grøndahl, a young sculptor, failed to persuade the Royal Copenhagen Porcelain Manufactory to reproduce the works of sculptor Thorvaldsen in "biscuit" (unglazed or porcelain fired twice at high temperatures but undecorated) porcelain. But he convinced the Bing brothers, M. H. and J. H., proprietors of a prosperous store in Copenhagen. With their capital and his ideas, the new company was started.

The early years, always difficult for a new business, were especially so for the Bing and Grøndahl enterprise. Before two years had passed, Grøndahl died. But the two Bing brothers persisted. Skilled craftsmen from abroad were hired and great improvements were made in the company's products. The company continued to gain recognition and win new customers, and in 1886 the company fortunes took a great leap forward. About that time, Bing and Grøndahl discovered the technique of underglaze painting. Prior to 1886, the porcelain produced by the company was either made in biscuit or overglaze porcelain. With the new technique, the porcelain was fired at 2,700 to 2,800 degrees F. All objects produced under this method had to be blue, since cobalt was the only color able to withstand the extremely high temperatures.

43

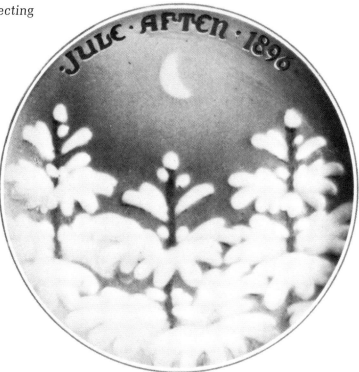

Bing and Grøndahl's
Christmas plate for 1896 is
entitled "New Moon over
Snow-covered Trees."

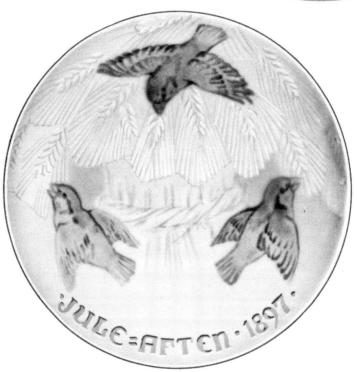

At Christmas it was the
custom of Scandinavian
farmers to fasten a sheaf
of wheat to a pole. The
wheat, which had been
saved from the harvest,
was the birds' Christmas
feast. The 1897 Christmas
plate commemorates
this tradition.

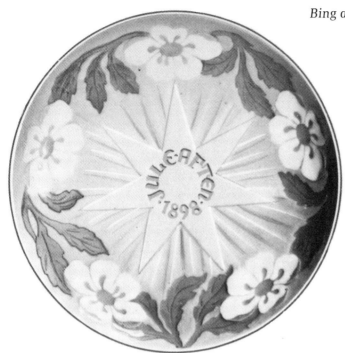

Fanny Garde designed the 1898 Christmas plate for Bing and Grøndahl. It was called "Christmas Roses and Christmas Star."

In the background of the 1899 Christmas plate entitled "The Crows Enjoying Christmas" is the ancient Notmark Church on the island of Als in Southern Jutland.

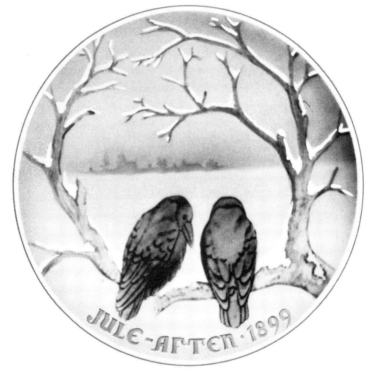

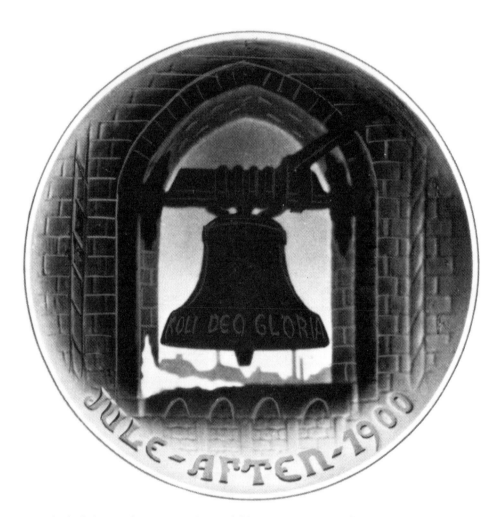

The bell depicted on Bing and Grøndahl's 1900 Christmas plate was cast in 1515.

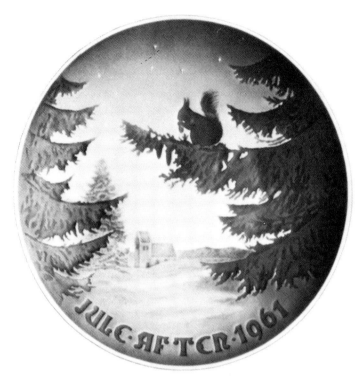

"Winter Harmony," the 1961 Christmas plate, was allegedly
inspired by an old Danish nursery rhyme about a squirrel.

Bing and Grøndahl introduced its new technique at the World Exhibition
in Paris in 1889. Its dinner service, called "Heron," was designed by Pietro
Krohn.

1895 was a landmark year for the company. With the Bing brothers
assured of controlling interest, the company became incorporated. Also, in
that year, Harold Bing, the president of the new firm, originated the idea
of the commercial Christmas Plate, utilizing the unique underglaze tech-
nique. The seven-inch blue and white plate was distributed shortly before
Christmas and was inscribed "Jule Aften 1895" (Christmas Eve 1895). Mr.
Bing's innovative marketing decision launched the collector's plate hobby.

Bing and Grøndahl has made a Christmas Plate every year since 1895.
Though the original plates sold for the equivalent of approximately twenty-
five cents, the company had to pay over $5,000 to acquire its third complete
set several years ago. A complete collection is on exhibit at the company's
museum in Copenhagen.

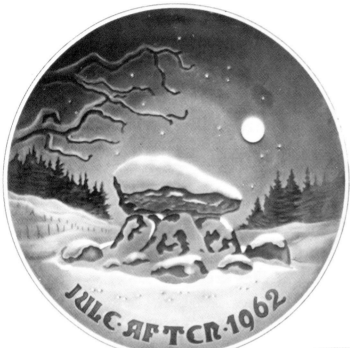

The countryside of Denmark is dotted with cairns, ancient monuments erected over the graves of long-ago tribal chieftains. A cairn at Mols in East Jutland is the subject of the 1962 plate.

The legend of the Danish Christmas elf, Jule-nissen, is depicted on the 1963 Christmas plate.

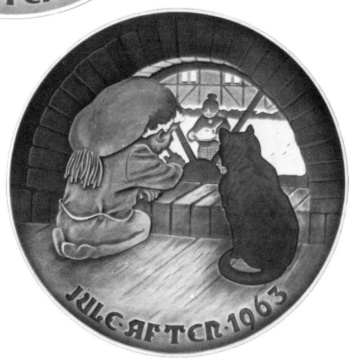

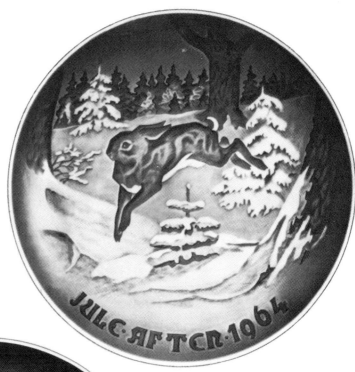

The 1964 Christmas plate was based on the Hans Christian Andersen tale "The Fir Tree."

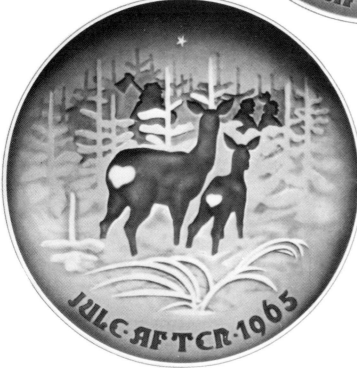

Entitled "Bringing Home the Christmas Tree," the 1965 Christmas plate commemorates the Danish custom of cutting one's own Christmas tree in Rebild Park in Rold Woods on the Sunday before Christmas.

The Christmas Plate by Bing and Grøndahl continues to be popular with collectors, and orders for the plates must be placed by June 30th. The fact that each piece is hand-crafted and signed with either the artist's name or initial enhances its value. Also prized by collectors are the Jubilee plates introduced in 1915. These are anniversary plates issued every five years and the design is taken from a previous Christmas Plate. In 1969, the company introduced its first Mother's Day Plate, which proved to be an overwhelming success with collectors. Originally issued at $6.00 the plate is worth over $200 on today's market. The company's trademark, Three Towers, which represents the coat of arms of the old city of Copenhagen, is found on each piece produced by the company.

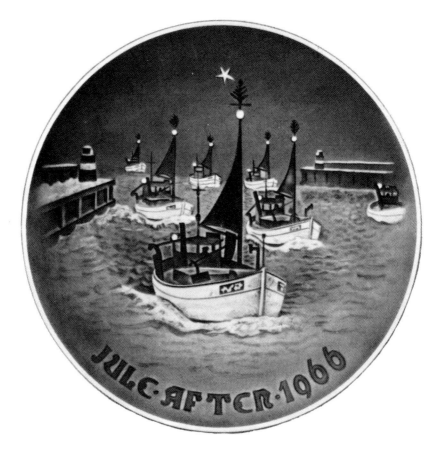

The ships on the 1966 Christmas plate have little spruce trees on their mastheads to signify the holiday season.

Bing and Grøndahl has always recognized the importance of having the finest artists create the designs for their objects. As early as 1900, J. F. Willumsen, the renowned Danish artist, was appointed art director. Effee Hegermann Lindencrone, Fanny Garde, Hans Tegner, Kis Nulsen, and Jean Gangruin are among some of the other acclaimed artists who have worked for the company.

From its inception, the Christmas Plate has portrayed Danish scenes though the subject is appropriate for Christmas. Many of the plates depict landmarks of Denmark, while others were inspired by ancient folk tales or Christmas traditions. The sea, which played an important part in Danish history, is another favorite subject.

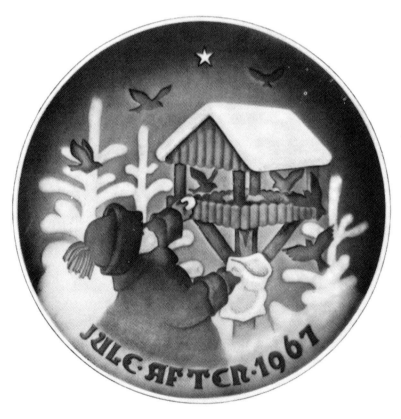

Henry Thelander, the artist for the 1967 Christmas plate, captures the true meaning of Christmas in the "Sharing the Joy of Christmas."

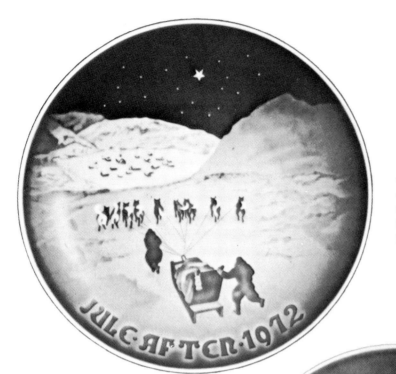

The starkness of the winter nights in Scandanavia is portrayed in the 1972 Christmas plate.

"Arrival of Christmas Guests" is the title of the 1969 Christmas plate.

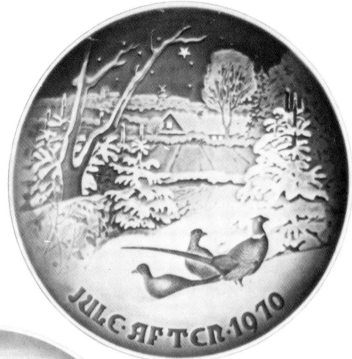

The 1970 Christmas plate is called "Pheasants in the Snow."

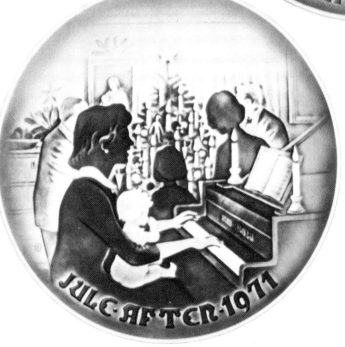

The 1971 Christmas plate, which depicts a quiet family gathering to celebrate the holiday, is aptly titled "Christmas at Home."

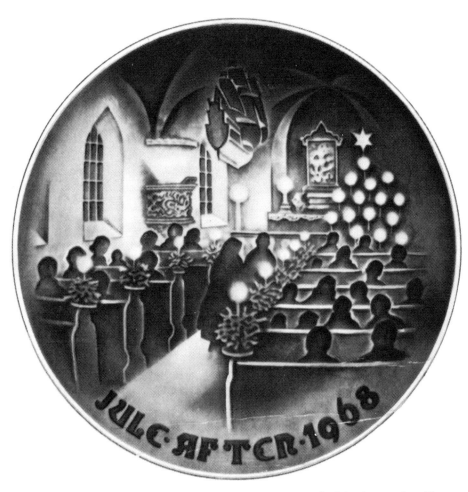

In Denmark the Christmas Eve church service is at 5 o'clock in the evening. The 1968 plate portrays church goers at the service. The ship hanging from the ceiling is a common sight in Danish churches.

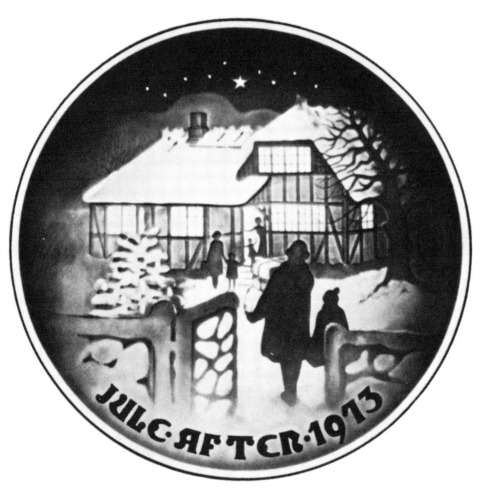

The 1973 Christmas plate depicts Christmas over, for another year.

The Boehm European Bird Plates produced by Boehm of Malvern, England.

EDWARD MARSHALL
BOEHM STUDIO

The Edward Marshall Boehm Studio in Trenton, New Jersey, is noted for its porcelain sculptures. The firm is named after its founder who, before he died in 1969, had gained world recognition for the beauty, grace and skill of his designs. Mr. Boehm, a former Maryland cattle farmer, had started his career by modeling hogs and horses in clay. Eventually his hobby grew more important to him. He wanted to give his clay animals permanence and color. Porcelain seemed to be the natural medium with which to achieve his goal.

However, the making of hard paste porcelain requires extensive technical knowledge. Boehm decided to learn all he could. He investigated the ceramics factories in Trenton, New Jersey, and spent long hours in libraries and museums. He spent six months experimenting with various kinds of clay till he mastered his own formula for making porcelain.

In the early stages of his venture, Boehm concentrated on producing vases and ash trays. Eventually he returned to his original love, animal sculpture.

In 1951, Helen Boehm quit her job to devote her time to selling her husband's work. It was quite difficult persuading the small gift and jewelry stores to order. Slowly, dealers who first bought one or two pieces as a favor began reordering. Sales increased, but it became apparent that it was the bird pieces (not the horse and dog sculptures) which were most in

demand. So Boehm decided to devote most of his energies to creating bird sculptures.

Eventually Boehm sculptures became prized possessions. Collectors waited years for particular pieces. Museums sought examples of his work. The term "Boehm Bird" became a recognized reference. Prestigious figures, such as American Presidents Eisenhower and Nixon, gave public recognition to Boehm. The demand for Boehm's early work grew intense and prices skyrocketed. A set of Song Sparrows, one of a limited edition of 50, sold for $50,000 at a New York auction in 1969. The original issue price was $2,000. The Boehm Robin, which originally sold for $600, is valued at approximately $4,000.

Reese Palley, the famed "Merchant to the Rich," discovered Boehm early. Today he is one of the most active dealers in Boehm sculptures. In the spring of 1974, Palley offered to sell a 137-piece collection of Boehm's work for $565,000.

In 1969, Helen Boehm, the wife of the artist and the business genius of the family, was invited to decorate the Oval Room in the White House. It was noted that neither a hawk nor the dove was represented in the exhibit. "No," President Nixon observed wearily, "I'm tired of all that." The comment inspired Helen Boehm to find a new peace bird. During her research she consulted ornithologists, scholars and statesmen. Finally, the mute swan, noted for its tranquility and serenity, was selected. The Boehm Studio sculptured a mammoth statue, weighing over 250 pounds, of two beautiful birds. The statue, hand-assembled and painted, is perhaps the largest work of its kind in the world. It is five and a half feet tall, four and a half feet wide, and two and a half feet deep. It was unveiled at the Congressional Club in Washington, D.C. and was exhibited at the American Embassies in London, Brussels, Bonn and Paris. The sculpture and the Boehm Studio captured the world's attention in 1971, when President Nixon presented the statue to Mao Tse-tung during his historic visit to China.

The statue inspired the Boehm Studio to produce its "Bird of Peace" Plate. It was issued early in 1972 and was limited to an edition of 5,000 plates. However, the edition was far more limited than the production numbers indicated. Plates were set aside for the White House and the American Embassies. The bone china plate is thirteen inches in diameter and the design called for a palette of fifteen hues. The wide intaglio border is filled with gold. Its issue price was $150, but the demand for the plates was so intense that the plate commanded several times its original price on the secondary market.

In 1973, the Boehm Studio issued "Young America 1776," which featured the young eagle as its subject.

The design for the thirteen-inch plate was adapted from the sculpture

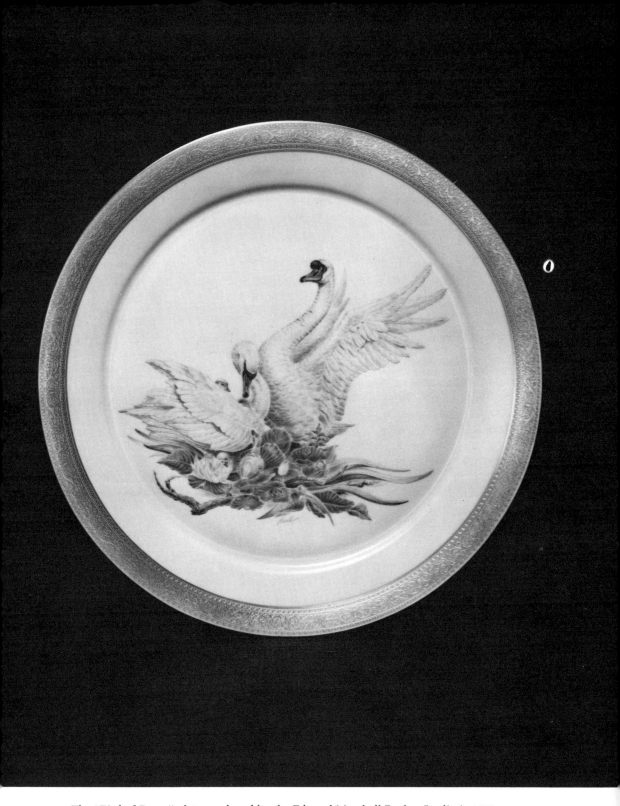

The "Bird of Peace" plate produced by the Edward Marshall Boehm Studio in 1972.

"Young America, 1776," the plate issued by the Edward Marshall Boehm Studio in 1973. The design is adapted from the sculpture "Young American Eagle."

"Young American Eagle." The original work was nine and a half inches high and was limited to an edition of 850 at an issue price of $700. The plate had a larger edition—six thousand were available worldwide. The issue price was $150. Both the "Bird of Peace Plate" and "Young America 1776 Plate" are manufactured by Lenox China.

The Boehm organization has a foreign counterpart: Boehm of Malvern, England Ltd. Boehm of Malvern is responsible for the set of eight limited issue plates depicting favorite birds of Europe. Species represented are Blue Tits, Chaffinch, Coal Tits, Goldcrest, Kingfisher, Swallows, and Tree Sparrows. Each plate portrays the male and female in a natural setting. The ten-inch plates are made of English bone china bordered with a double band of pure gold. The edition was limited to 5,000 sets. Except for the Reese Palley Boehm of Malvern Plate Club, which allows a subscriber to purchase the set at the rate of one a month for $50.00, the plates are available only in Europe.

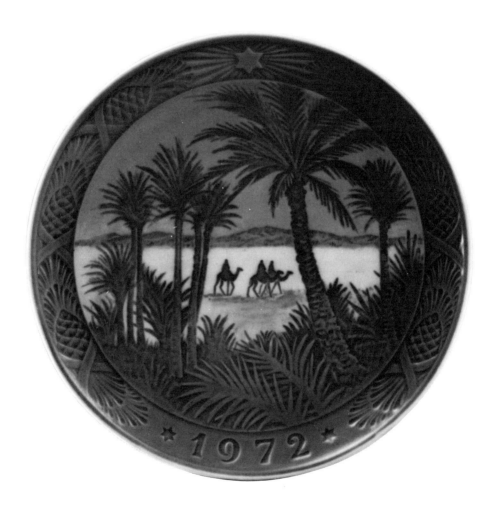

The Three Wise Men crossing the desert are depicted on the 1972 Christmas plate.

ROYAL COPENHAGEN

Royal Copenhagen of Denmark has as its trademark three wavy lines, which represent three Danish waterways—the Sound, the Great Belt, and the Little Belt. This trademark, which is world-famous, has identified Royal Copenhagen porcelain since 1775. Originally owned by the Royal Family of Denmark, the company became a private company in 1882. Though the company produced commemorative plates for such occasions as royal golden wedding anniversaries since 1888, the first Christmas plate was not introduced until 1908.

Frequently the designs for Royal Copenhagen's plates have been selected from entries submitted by employees of the company. Other designs were created by artists commissioned by the company. Once the design is approved, a craftsman carves the picture in a plaster mold. All subsequent molds are fashioned from the original. A mold has a short life span and is used only twenty or twenty-five times before it is destroyed.

In its embryonic stage, a plate is a mere lump of clay. The components of the clay are kaolin, quartz and feldspar. It is interesting to note that Denmark is devoid of almost all natural resources needed for porcelain. Thus, kaolin is imported from Great Britain, while quartz and feldspar are obtained from Norway and Sweden. These materials are housed in huge silos until needed.

After the decision is made to begin, the materials are painstakingly

weighed, mixed, and poured into the ball-mill. The ball-mill is a big revolving cylinder containing balls of flint. Water is added to the mixture to create a milky liquid. The liquid is filtered and all excess water is eliminated. The substance remaining is a paste ready for the next step—the turning room.

A piece of the porcelain is thrown on the potter's wheel and is pressed flat to resemble a pancake. The "pancake" is then fitted on the plaster mold. Then the potter places it on another wheel from which the profile (sometimes referred to as the "jigger") drops to shape the underside of the plate in the "bat" of clay. The upper side of the plate is formed simultaneously by the surface of the mold.

Once the plate is molded, it is set aside to dry. It is then fired at 1,750° F. (biscuit firing). Upon completion of the firing the plate is hand painted in the traditional cobalt blue. Then each plate is dipped into the glaze. A dull, gray-white film covers the plate, obscuring the cobalt blue. The plate then undergoes its final firing, this time at 2,650° F. The firing causes the glaze to liquefy and become transparent. The familiar cobalt blue reappears beneath the glaze.

The company is scrupulous about maintaining its standards of excellence. Each plate is closely checked for imperfections during each step of the process. Accordingly, any plates which fail to meet the standards are designated seconds, or even thirds. The imperfect plates carry a mark. A diagonal strike is drawn through their trademark. One strike represents a second (second sorting) and two strikes mark a third (third sorting).

STANDARD MARK SECOND

In 1923, Oluf Jensen designed a pine cone for the plate's border and since that time all Royal Copenhagen Christmas plates have retained the design for the border. Though the first plate, "Maria with Child" in 1908, was six inches in diameter, all plates made since 1913 are seven inches across. The custom of using only the Danish text began in 1945. Prior to that time the company issued plates in English, German, French, Czechoslovakian, and, for a period of time, Dutch.

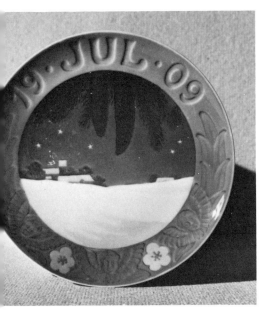

Royal Copenhagen's second Christmas plate, 1909, was a snow landscape.

The 1910 Christmas plate depicts the adoration of the Magi.

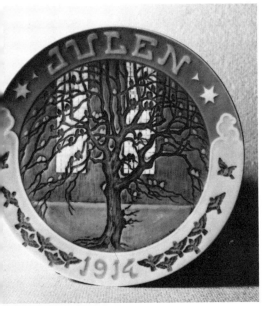

The window of the Church of the Holy Ghost in Copenhagen is the background of the 1914 Christmas plate.

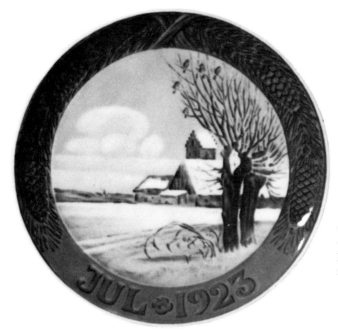

The 1923 plate was a
traditional snowcovered
landscape with a church
in the background.

A schooner at sea on
Christmas night is the
subject for the 1924
Christmas plate.

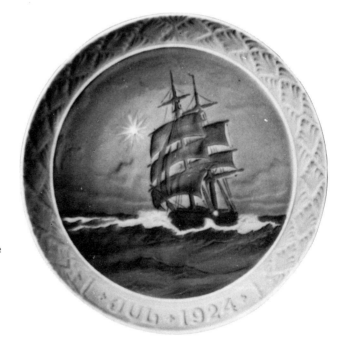

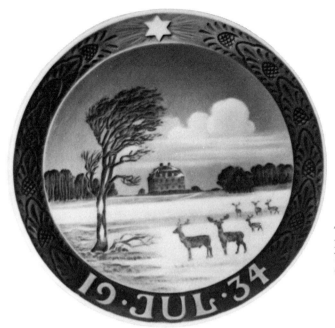

The hunting lodge Eremitagen is in the background of the 1934 Christmas plate.

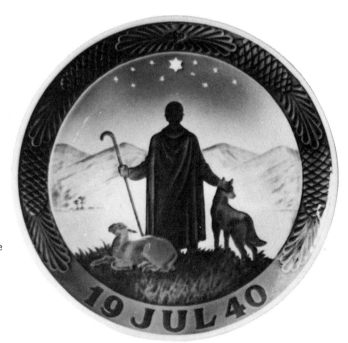

The 1940 Christmas plate shows a shepherd in a desert.

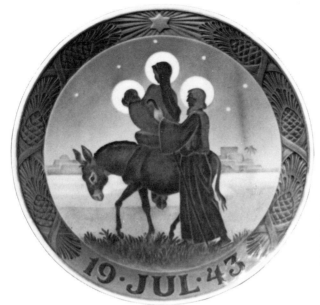

Viggo Olsen designed the 1943 Christmas plate entitled "The Flight to Egypt."

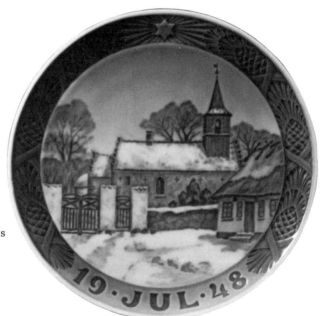

The Church at Noddebo is the subject of the 1948 Christmas plate.

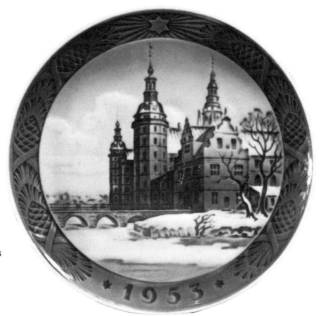

Frederiksborg Castle in
Hillerod is the scene
chosen for the Christmas
plate of 1953.

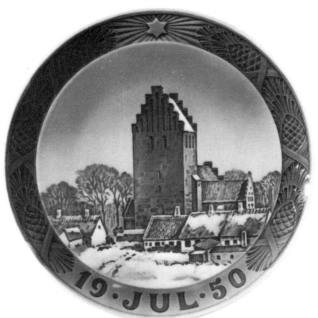

The Christmas plate of
1950 featured the Church
at Boeslunde.

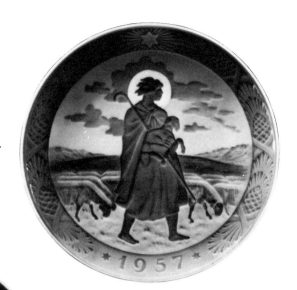

Hans Henrik Hansen
designed the 1959
Christmas plate, which
shows an angel playing for
the animals in the forest.

The 1957 Christmas plate
shows a shepherd with
his herd.

The famous sculpture
"The Little Mermaid" by
Edvard Eriksen is the
subject for the 1962
Christmas plate.

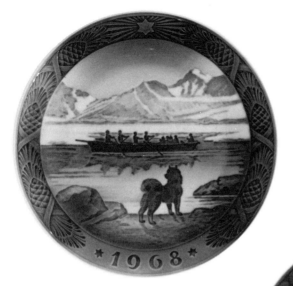

Kay Lange designed the 1968 Christmas plate which depicts the last umiak in Greenland. A umiak is a boat rowed by a woman.

The 1971 Christmas plate features a rabbit in a snow scene.

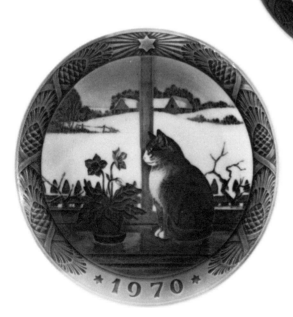

The 1970 Christmas plate shows a cat on a windowsill looking over a snowcovered farm.

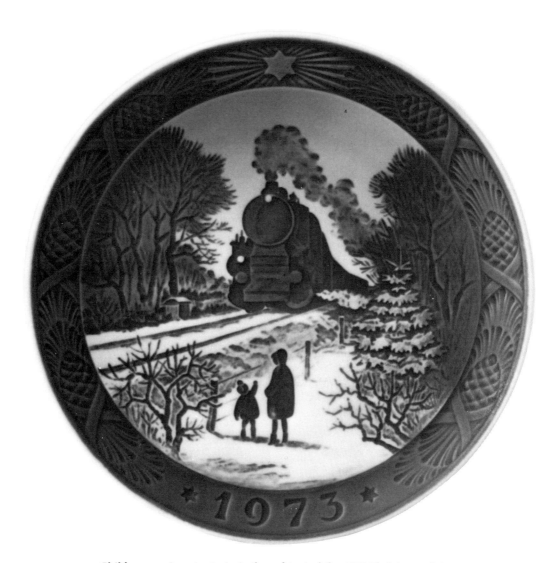

Children waving at a train is the subject of the 1973 Christmas plate.

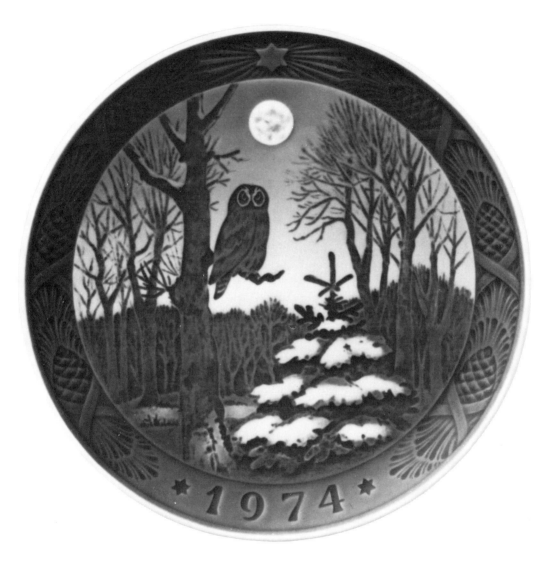

An owl perched on a limb with the moon behind him is the scene depicted in the 1974 Christmas plate.

"The Small Cowper Madonna," was Fenton's 1973 Mother's Day plate.

THE FENTON
ART GLASS COMPANY

Frank and John Fenton established the Fenton Art Glass Co. in 1905. Their initial capital was limited to approximately $300, so in the early years the company's activities were devoted to decorating blanks obtained from other manufacturers. The original location in Martins Ferry, Ohio, was transferred to Williamstown, West Virginia, in 1906, because of difficulties in securing blanks and the brothers' desire to develop a glass making company. By 1907, the company had achieved fame by introducing a new type of glass called Iridescent Glass. Now known as Carnival glass, iridescent glass scored an immediate success with the public. The popularity of Carnival glass contributed greatly to the company's growth. Fenton hailed its significance in its letterhead, which proclaimed "Originators of Iridescent Ware."

The company's headquarters remain in Williamstown, West Virginia, and sons of the founders retain control. Carnival glass is currently experiencing a revival and the company is reissuing many of its more famous pieces originally made in the early part of the century.

Fenton's first entry in the collector plate market was introduced in January 1970. "The American Craftsman Series," designed by Anthony Rosena, began with the "Glassmaker" plate. The eight-inch plate is made of Carnival glass with a deep amethyst background. The handmade plate commemorates the earliest craftsman of new America . . . Jamestown, 1608. It is most

fitting that the figure in the scene is that of the glass worker depicted in the Fenton trademark. The legend "No. 1 in the annual series of collector's plates by Fenton" is embossed on the back of each plate. With the exception of the 1974 plate, which was issued at $11.00, all the plates originally retailed at $10.00.

The second plate in the series saluted the printer. Each plate of the 1971 edition carried the following inscription on its back.

> With this handmade plate, Fenton commemorates the earliest printer of Colonial America. This printing press was set up in Cambridge, Mass. by Stephen Daye in 1638. He printed the first book in English America, "The Bay Psalm Book"—1640.

The blacksmith was the subject of the 1972 plate in the "American Craftsman Series." James Read, who arrived with the original group of settlers in Jamestown, Virginia, May 13, 1607, is the blacksmith commemorated.

Thomas Beard, a skilled cordwainer (shoemaker) who came to Salem, Mass., in 1629, is the subject of the 1973 plate in Fenton's "American Craftsman Series."

The pioneer coopers and their barrel and cask making skills are celebrated in the 1974 Fenton plate. All of the plates in the series are issued in limited editions with the molds destroyed on December 31st of the year issued.

Fenton initiated its Christmas Plate series in 1970. Anthony Rosena, the artist for all of Fenton's plates, chose to depict the First Congregational Church of Bradford, Iowa. The plate's title, "The Little Brown Church in the Vale," was inspired by the beautiful setting in which the church stands. Once before, in 1857, the setting had served as an inspiration. Dr. William S. Pitts wrote the hymn "The Church in the Wildwood" after he had visited the site. Several years later he returned to find that a church had actually been built in the grove. The eight-inch plate is available in Carnival glass with a deep amethyst background and also in Blue Satin glass and originally retailed at $12.50.

Fenton's Christmas Plate for 1971 depicted "The Old Brick Church," the oldest Protestant Church in America. The oldest Gothic church in the country, it is located on the James River near Jamestown, Virginia, and was built in 1632. It too was made in Carnival glass and Blue Satin glass and issued for $12.50.

"The Two Horned Church," Fenton's 1972 Christmas plate, depicts a church in Marietta, Ohio. It was given its distinctive name by rivermen, "who watched for the lights from its tall, twin spires against the sky, a landmark they could see for miles." Fenton made the plate in White Satin (milk glass) as well as Carnival glass and Blue Satin. It was issued at $12.50.

St. Mary's in the Mountains in Virginia City, Nevada, also referred to as

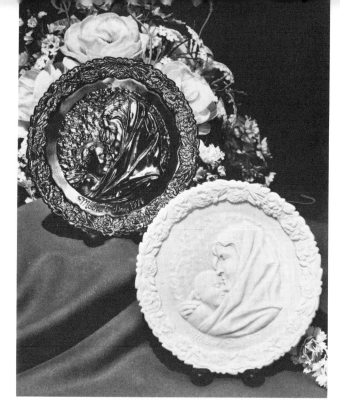

Fenton Art Glass introduced its first Mother's Day plate in 1971. Entitled "Madonna with the Sleeping Child," it was available in Carnival glass and Blue Satin glass.

"Madonna of the Goldfinch," (1972) was the second plate in Fenton's Mother's Day series. It was made in Carnival, Blue Satin, and White Satin glass.

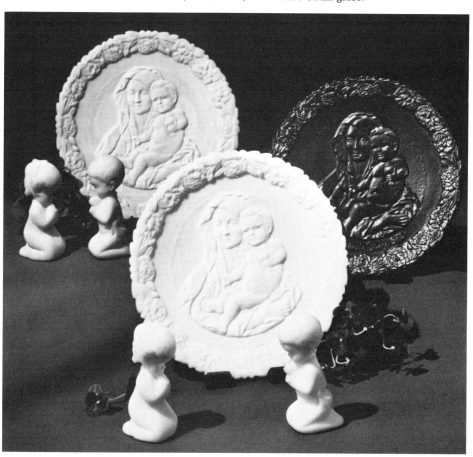

the "Cathedral on the Comstock," has the subject of Fenton's Christmas plate for 1973. The plate was made in Carnival glass, Blue Satin, and White Satin and retailed for $12.50. The molds for all the plates are destroyed on the last day of the year of issue.

Fenton's Mother's Day series features reproductions of world-famous Madonnas. The first plate, issued in 1971, was entitled "Madonna with the Sleeping Child." The original glazed terra cotta relief has been attributed to Mechelozzo, a fifteenth century artist of the Florentine school. Anthony Rosena designed the plate for Fenton. The 1971 plate was available in Carnival glass and Blue Satin and retailed for $12.50.

The 1972 Mother's Day plate featured "Madonna of the Goldfinch," painted in 1760 by Giovanni Battista Tiepolo. Tiepolo is considered to be the last great master of the Venetian school of painting. The goldfinch is symbolic of the Passion of Christ, because of its fondness for feeding on thistles and thorns.

Raphael's "The Small Cowper Madonna (1505)" was the subject of Fenton's 1973 Mother's Day plate. The fourth in the series (1974) depicted Karl Muller's "The Madonna of the Grotto."

All the plates in the series, with the exception of the 1971 issue, were available in Carnival, Blue Satin and White Satin glass. The retail price was $12.50 for every plate but the 1974 issue, which was increased to $13.50.

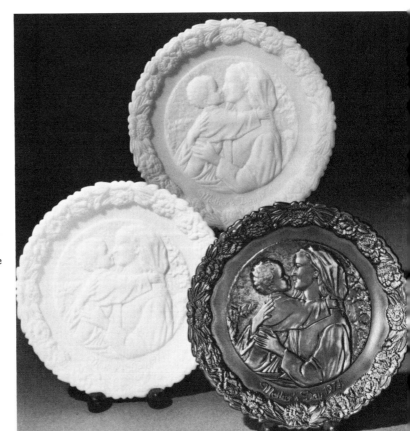

Fenton Art Glass commissioned Anthony Rosena to create its 1974 Mother's Day plate entitled "Madonna of the Grotto." Mr. Rosena has been the artist for the entire series.

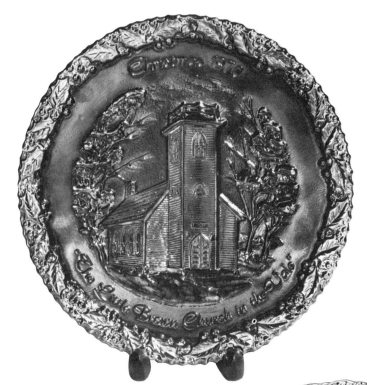

In 1970, Fenton Art Glass introduced its Christmas in America Series. The first plate entitled "The Little Brown Church in the Vale," was available in Carnival class and Blue Satin glass.

Anthony Rosena designed all the plates in Fenton's Christmas in America Series. The 1971 edition was called "The Old Brick Church."

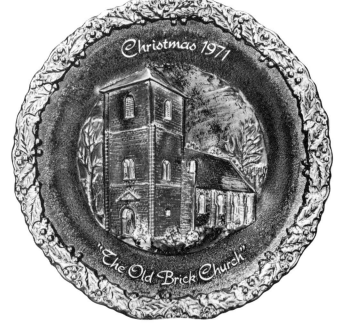

"The Two Horned
Church," Fenton's 1972
Christmas plate was
available in customary
Carnival glass, Blue Satin
glass, as well as White
Satin glass.

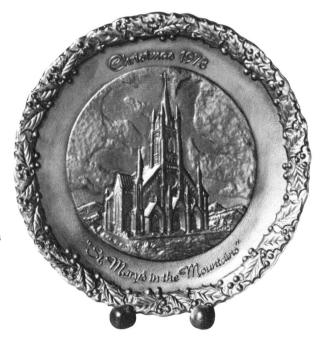

"St. Mary's in the
Mountains" was Fenton's
1973 Christmas plate.

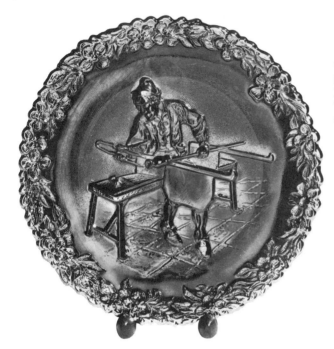

The American Craftsman
Series was introduced by
Fenton Art Glass in 1970.
The first plate depicted
the Glassmaker.

The Printer was the
subject of the 1971 plate
in Fenton's American
Craftsman Series.

Anthony Rosena, the artist for Fenton's The American Craftsman Series, chose the Blacksmith for the 1972 plate.

"The Shoemaker or Cordwainer," issued in 1973, was the fourth in Fenton's The American Craftsman Series.

"The Cooper," the 1974 plate in Fenton's American Craftsman Series, was made of Carnival glass.

Stevan Dohanos chose the traditional turkey as the subject for Franklin Mint's 1973 Thanksgiving plate.

FRANKLIN MINT

More than any other company, Franklin Mint must be given credit for revolutionizing the world of collector plates. Through his sophisticated merchandising and sales techniques Joseph M. Segel, the founder of Franklin Mint, made "collecting" big business.

The Franklin Mint, the world's largest private mint, larger even than some government mints, is a relatively young company. Its founding illustrates the truth of the adage "Necessity is the mother of invention." In the early 1960s, Mr. Segel had conceived the idea of a collector's group, The National Commemorative Society, which would issue its own series of sterling silver limited edition commemorative coin medals. Mr. Segal had no problems in recruiting members—5,000 enthusiasts joined immediately. However, the new organization encountered a major difficulty. A good private mint to produce the medals was unavailable for various reasons. Not to be deterred, Mr. Segel persuaded Gilroy Roberts, the then Chief Sculptor Engraver for the United States Mint to join him in founding the Franklin Mint. The company became enormously successful and eventually captured the hearts of Wall Street when it went public in the late 1960s.

In 1970 the company's new headquarters were moved to Franklin Center, Pennsylvania (just outside of Philadelphia). The new plant, which reportedly cost ten million dollars, has the finest automated continuous silver casting lines in the world. Approximately 50,000,000 ounces of silver (more

than all the mines in America produced in a year) are melted, cast, and rolled annually. The "clean room" at the new plant is an example of the modern technological techniques employed by the company. Air in the "clean room" is changed every ninety seconds. Employees in this section must wear plastic gloves and lint-free uniforms at all times. Protective covering is used to seal each proof quality coin before it leaves the "clean room."

Franklin Mint chose the esteemed American artist Norman Rockwell to design its first collector plate. The plate, which was eight inches in diameter, was made of sterling silver and weighed 5.5 ounces. It marked the first time a collector plate had been produced in silver. It was also the first time Rockwell had worked in silver. The plate, the first in a series of six to be designed by Rockwell, was entitled "Bringing Home the Christmas Tree." A father is shown carrying the family Christmas tree followed by his son carrying the axe. As is his custom, Rockwell used two New England neighbors, George Emerson and his son Scott, as his models. The puppy seen in the bottom left of the plates was a last-minute inspiration and no live model was used.

The plate had an original issue price of $100 and was distributed through Franklin Mint's normal subscription list and various retail dealers. Orders from Franklin Mint subscribers were accepted by mail and August 23, 1970, was the final date. A reported 12,200 plates were sold in this manner.

Retail distribution proved a problem for the company. As described in another section of the book, major department stores and specialty firms were reluctant to book orders on the plates.

However, a reported 6,121 plates were sold through these channels. Currently the company has attempted to eliminate the retail distribution of its plates and rely solely on its own subscribers. Only a select number of Franklin Mint dealers are allocated plates. The company continues to use a cut-off date for orders as the means for limiting editions.

The 1971 Christmas plate was entitled "Under the Mistletoe," the 1972 plate "The Carolers," and the 1973 plate "Trimming the Tree."

In 1972 Franklin Mint introduced its Mother's Day plate. Called "Mother and Child," the design was an original work of art by Irene Spencer. The sterling silver plate had an original issue price of $125.

The 1973 plate for Mother's Day was similar in all respects—title, composition, price, etc. Irene Spencer created another original work of art to depict the same theme.

In 1973 the company introduced its first Easter plate. Entitled "The Resurrection," the plate was designed by the highly acclaimed sculptor Evangelor Frudakis, winner of the prestigious Prix de Rome. The plate was unique to Franklin Mint. It was the first time it had produced a sculptured plate composed of both gold and silver. The plate itself is made of sterling

Franklin Mint's first collector's plate was introduced for Christmas
1970. Entitled "Bringing Home the Tree," it was the first of six in
a series to be designed by the beloved American artist,
Norman Rockwell.

Franklin Mint's 1971 Christmas plate, "Under the Mistletoe,"
is a typical Rockwell scene.

silver, and the sculptured image is 24k gold heavily electroplated on the sterling. It was issued at $175 per plate.

A Western Plate Series was inaugurated in 1972 with "Horizons West," designed by Richard Baldwin. The eight-inch plate represented the first sculptured plate produced by Franklin Mint. It was available in both sterling silver at a price of $150 or in solid 24k gold for $2,200. The silver plate contains approximately eleven troy ounces of sterling silver while the gold plate has twenty-one ounces of 24k gold.

According to the company, only 5,860 silver plates and sixty-seven gold plates were minted for each edition. The total represented the number of orders received for the first plate in the series.

The series continued with "Mountain Man" by Gordon Phillips. L. E. Gus Shafer, a sculptor noted for his works about the American West, designed "Prospector," the third plate in the series. "Plains Hunter" by John Weaver concluded the series in 1973.

"The Caroler," Franklin Mint's 1972 Christmas plate features a self-portrait of the artist, Norman Rockwell.

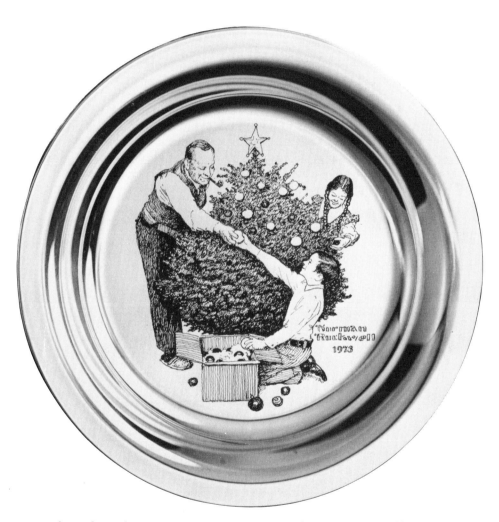

The traditional scene "Trimming the Tree" was the subject of Franklin Mint's 1973 sterling silver Christmas plate.

Franklin Mint commissioned Richard Evans Younger to create a series of four plates in 1972. Mr. Younger, an esteemed American wildlife artist, selected four of America's most popular birds as the subject for his designs. The eight-inch plate was made of sterling silver and was issued at a price of $125. The first plate featured "The Cardinal," the second "Bobwhite," the third "Mallards" and the final one the "American Bald Eagle."

"Along the Brandywine" was the title of the first sterling silver plate created by James Wyeth for Franklin Mint in 1972. It was an original work of art created specifically for Franklin Mint.

The second plate in the projected series of five was entitled "Winter Fox." Wyeth's scene shows a startled fox about to break and run. According to the artist, the incident depicted on the plate actually occurred on a December afternoon. He had been walking up the hill beyond his farm to look at his home in the valley in bright snow.

In 1972 Franklin Mint introduced a series of sculptured Western plates. "Horizons West," the initial plate of the series was created by Richard Baldwin.

The second in the series of four Western plates produced by
Franklin Mint was entitled "Mountain Man." Designed by Gordon
Phillips, the plate was available in both sterling silver and 22k gold,
as is the custom for many of the Franklin Mint plates.

L. E. "Gus" Shafer created "Prospector," the third plate in
Franklin Mint's Western series.

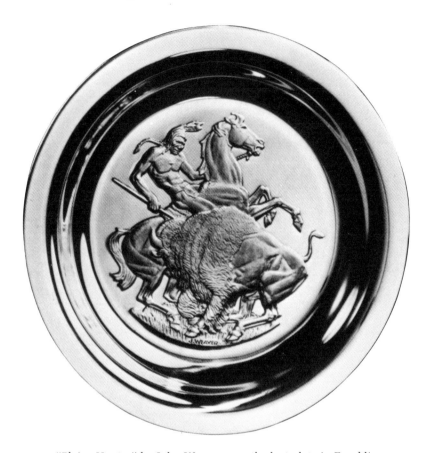

"Plains Hunter" by John Weaver was the last plate in Franklin
Mint's Western Plate series.

"As I came back over a ridge," he recalled, "I suddenly saw the fox, with
the farm in the background, and beyond, Brandywine Creek."

The Wyeth plates are eight inches in diameter and were available to
Franklin Mint subscribers and certified dealers for $125.

The prolific Franklin Mint produces several other plates. There is a series
of Thanksgiving plates, a series of plates which features portraits of Amer-
ican Presidents, and in conjunction with the National Audubon Society, a
series of four plates based on works by John James Audubon. The first plate,
issued in 1973, depicted "The Wood Thrush" at a price of $150. The Bicen-
tennial Council of the Thirteen Original States chose Franklin Mint to pro-
duce its first official Bicentennial Commemorative Plate. Entitled "Jefferson
Drafting the Declaration of Independence," it combines sculpture with
gold inlay. The plate itself is solid sterling silver but the sculptured scene
is in 24k gold electroplated on sterling. The quote "We hold these truths to

be self-evident" and the name Thomas Jefferson are etched and inlaid with 24k gold. Three other plates will complete the series. All of the plates will be issued at a price of $175 each.

The Thanksgiving plate was introduced in 1972. Stevan Dohanos, illustrator and artist, was commissioned to design the first plate in the series. The 1972 plate was entitled the "First Thanksgiving" and it depicted the Pilgrims and Indians preparing the first holiday feast. The second plate featured the "American Wild Turkey." Both plates were eight inches in diameter, sterling silver, and issued at $125.

Franklin Mint introduced its first porcelain collector plate in 1975. The Hans Christian Andersen plates, a colorful collection of twelve porcelain plates, were produced by Royal Copenhagen especially for Franklin Mint. In February 1976 the firm announced the formation of two new divisions, Franklin Porcelain and Franklin Crystal.

The first offering of Franklin Porcelain was a series of twelve plates entitled "Flowers of the Year Plate Collection." The world renowned floral designer Leslie Greenwood of Great Britain was chosen to create the plates which are being issued under the auspices of the Royal Horticultural Society of Great Britain, the oldest such organization in the world.

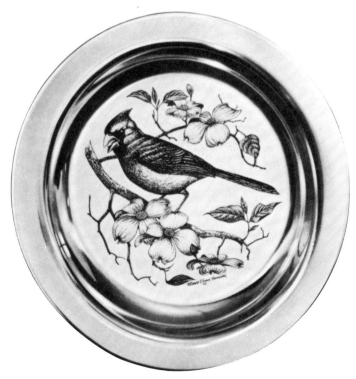

Birds, a traditional and popular subject for porcelain manufacturers was chosen by Franklin Mint for a series of four plates etched in silver. "The Cardinal" by Richard Evans Younger was the first plate.

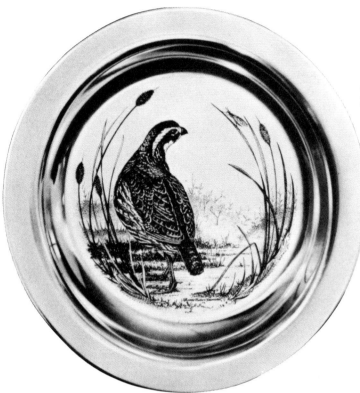

"Bobwhite" was the title of the second plate in Franklin Mint's bird series.

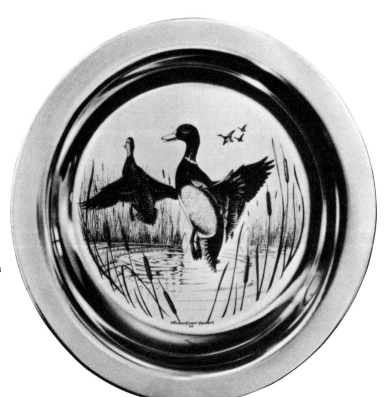

The third plate in Franklin Mint's bird series was called "Mallards."

In 1972, Franklin Mint introduced the first in a series of five collector's plates designed by James Wyeth. It was entitled "Along the Brandywine."

The final plate in Franklin Mint's bird series was "American Bald Eagle."

"Winter Fox" was the second plate in Franklin Mint's Wyeth series.

Irene Spencer designed
Franklin Mint's first
Mother's Day plate (1972),
entitled "Mother and
Child."

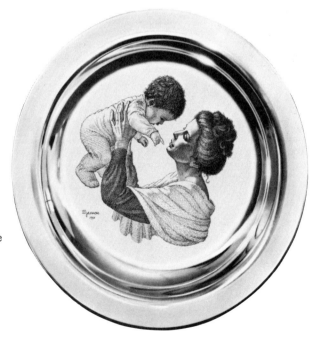

Franklin Mint utilized the
same artist and title for
its 1973 Mother's Day
plate.

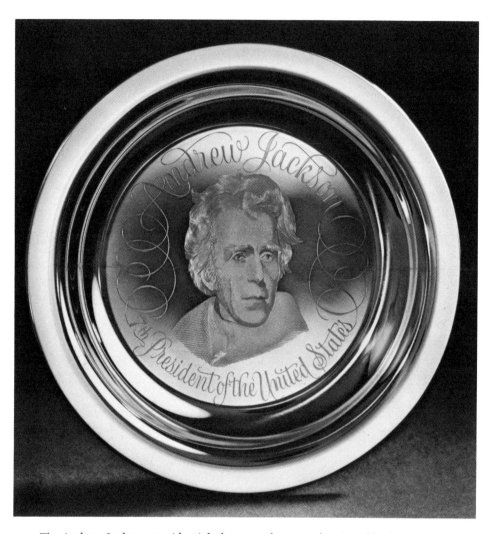

The Andrew Jackson presidential plate was the seventh in Franklin Mint's series of Presidential portraits.

Franklin Mint introduced its first Thanksgiving plate in 1972. The sterling silver plate was designed by Stevan Dohanos.

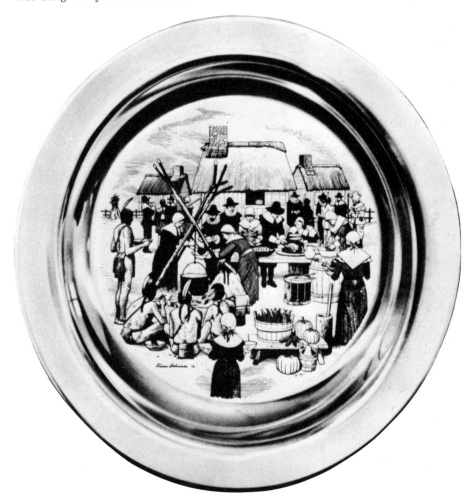

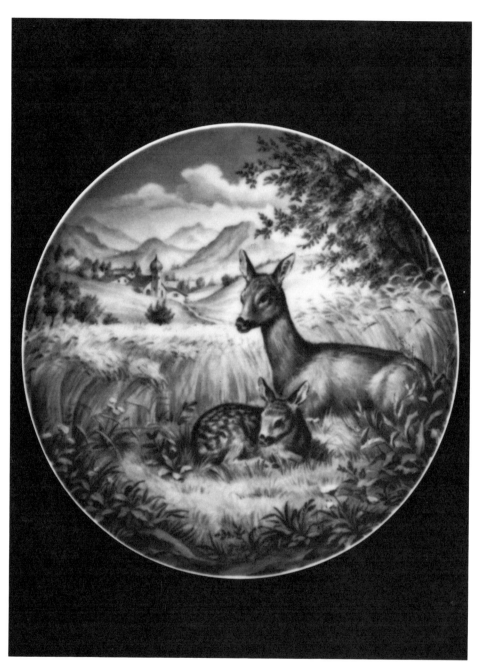

Fürstenberg's 1974 Mother's Day plate has a mother doe with her fawn as its subject.

FÜRSTENBERG

Fürstenberg, the oldest porcelain factory in West Germany, was founded in 1746 by Duke Charles I of Brunswick. Under his direction the old Castle of Fürstenberg was chosen for the site of the factory. Despite numerous wars and natural calamities, the company survived. It enjoyed surges of success under the management of Kohl and Gernot during the years 1770-1790 and 1795-1814 respectively. It was granted the title "Royal Manufactory of Porcelain" in the early 1800s. Since its inception, the company has used the same trademark—a blue "F" initialed under the glaze.

Fürstenberg produces several series of plates, including Easter, Christmas, Deluxe Christmas, and Mother's Day. Fürstenberg introduced its Easter plate series in 1971. The 7½-inch plate is of cobalt blue and white underglaze. The 1971 plate featured a family of lambs in a tranquil pastoral scene. There were only 3,000 plates in the 1971 edition, and an individual plate retailed for $13. Fürstenberg's 1972 Easter plate depicted a group of chicks in their nest. The 1972 plate retailed for $15.00, and the edition was increased to 6,000 pieces. Fürstenberg's third annual Easter plate, issued in 1973, reflected a traditional Easter theme—Easter bunnies. The 1973 edition was limited to 4,000 plates, with an individual plate retailing for $16.00. Churchgoers on their way to Easter services is the subject of the 1974 plate designed by I. Jobaries. For the 1974 edition only 4,000 plates were produced, each retailing for $20.00.

Fürstenberg inaugurated its Mother's Day series in 1972. A graceful hummingbird tending to her young was the scene depicted on the first plate. The 7½-inch plate was of white and blue underglaze. The issue comprised 7,500 pieces and each plate retailed for $15.00. The second plate in the series featured a mother hedgehog and her baby. The issue was limited to 5,000 plates which retailed for $16. A mother doe with her fawn was the subject of Fürstenberg's 1974 Mother's Day plate. Only 4,000 plates were issued and the issue price was increased to $20.00.

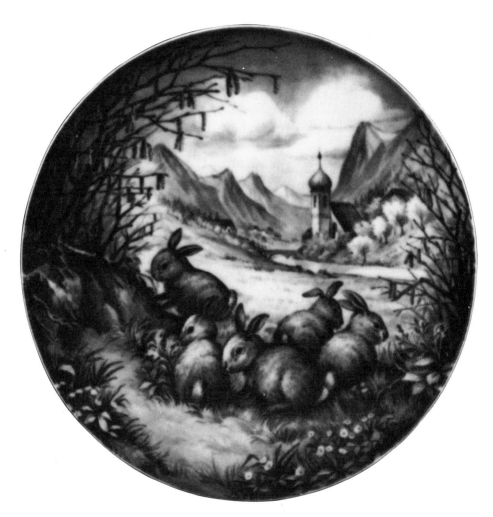

Another traditional Easter scene—bunnies resting before a mountain church is the subject for Fürstenberg's 1973 Easter plate.

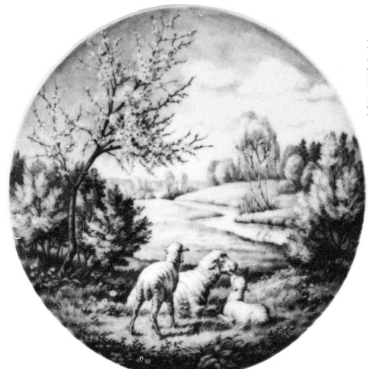

Fürstenberg introduced an annual Easter plate in 1971. The first plate features a family of sheep resting in a spring landscape.

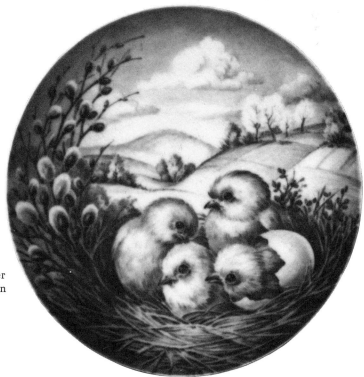

Fürstenberg's 1972 Easter plate has Easter chicks in their nest as its subject.

Fürstenberg's 1974 Easter plate was designed by I. Jabries.

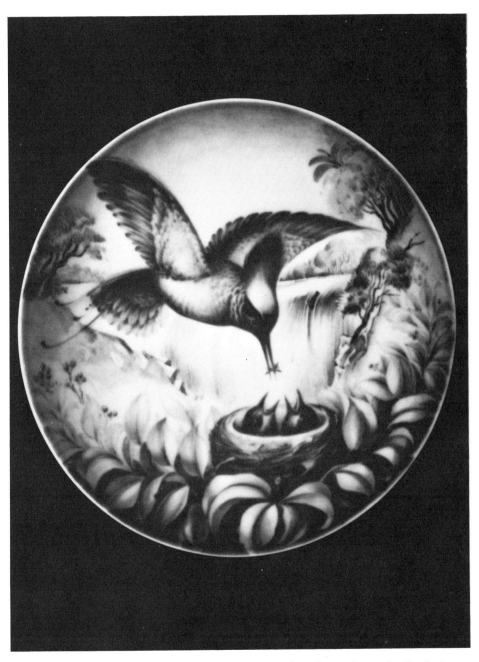

A graceful hummingbird feeding its young was the subject chosen for the first Fürstenberg Mother's Day plate introduced in 1972.

In 1971 Gorham introduced its Gallery of Masters Series with "Man in Gilt Helmet" by Rembrandt.

GORHAM

The Gorham Company began as a small silver company in 1818. Today the company is more diversified, producing china, crystal, electronic equipment, and various industrial products. However, the company retains its ranking as the leading manufacturer of sterling silverware in the world.

For many years the Gorham Company was strictly a family enterprise. The founder, Jabez Gorham, was fourteen when he became an apprentice in a silver shop in 1806. After twelve years, he started his own business, and by 1831 he was engaged in the making of silver spoons. His son, John, followed his lead and joined the business in 1841. John Gorham expanded the business by installing equipment to manufacture flat silver and hollow ware. The younger Gorham possessed a great deal of resourcefulness. If he could not purchase the machines he required, he adapted existing ones or designed his own. Skilled silversmiths were imported from England.

The company continued to flourish and by 1863 Rhode Island granted it a charter. In 1865, the company expanded further. Objects in sterling silver, gold, brass, stone, and wood were produced for churches and other ecclesiastical organizations. Eventually the company was commissioned to create statues and memorials in bronze. Today Gorham has one of the world's largest foundries. The "Mustang" group at the University of Texas and the statue of Theodore Roosevelt outside the Museum of Natural History in New York City are two of the company's more famous contributions to the world of architectural art.

Gorham chose an interesting way to make its debut in the collector plate market. In 1971, Norman Rockwell created a series of four plates entitled the "Four Seasons." The first set depicted the theme "A Boy and His Dog." The plate for winter was called "A Boy Meets His Dog," spring, "Adventures Between Adventurers," summer, "A Mysterious Melody," and fall, "Pride of Parenthood." The boy in the plate is Jared, but the dog named Charlie should have been named Charlene. The plates are ten and a half inches in diameter and are trimmed in 24k gold. The set of four plates retailed for $50.00. Gorham limited the edition, but no exact figures are available.

In 1972, Rockwell chose the theme "Young Love" and in 1973 "The Four Seasons of Love." The 1972 and 1973 sets retailed for $60.00.

In 1971, the Gorham Gallery of the Masters series was introduced. The first plate was "Man in Gilt Helmet" by Rembrandt, followed by "Self-Portrait with Saskia," also by Rembrandt, in 1972. Both were done in full color with a 24k gold floral border. The 1973 issue was the "Honorable Mrs. Gorham" by Gainsborough. Each of the three plates retailed for $50.00.

Another series produced by Gorham is the etchings of Lionel Barrymore. Mr. Barrymore, famous as an actor, was also a talented graphic artist. "Quiet Waters" and "San Pedro" were the titles for the 1971 and 1972 plates respectively. The etchings are in black on fine china, and Gorham's sterling silver disc appears on the back. The plates were issued at $25.00.

Gorham also chose Barrymore's etchings for a series of silver plates inaugurated in 1972.

Several other plates are produced by the company, including the "Twelve Days of Christmas" series for the Traditional Jewelers of America Plate introduced in 1971. A Bicentennial series, a Frederick Remington set, an annual Christmas plate, and a Mother's Day series are among other issues made by Gorham.

Gorham chose another Rembrandt, "Self Portrait with Saskia," for the 1972 plate in its Gallery of the Masters Series.

Pictures on these two pages depict Norman Rockwell's Four Seasons Plates for 1973. Third in the series produced by Gorham the 1973 edition is entitled "Four Seasons of Love."

"Burning of the *Gaspée*" (1972) was the first limited pewter plate made by Gorham.

Gorham also recreated the
"Burning of the *Gaspée*"
in sterling in its
Bicentennial plate
introduced in 1972.

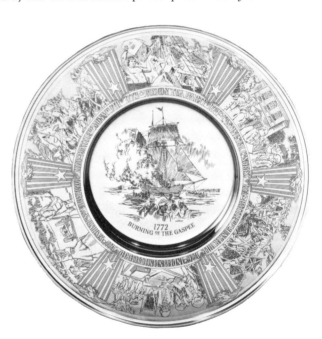

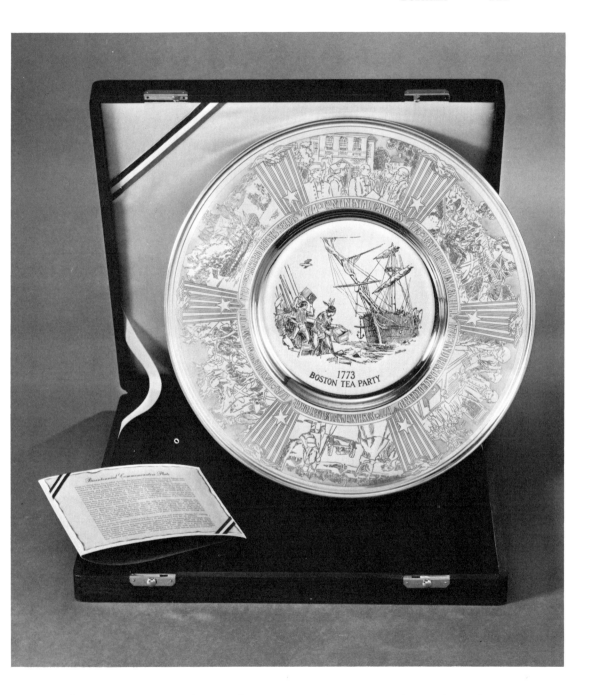

"The Boston Tea Party," the second plate (1973) in the Bicentennial Series by Gorham was also in sterling silver.

The first plate in a series of twelve produced by Haviland & Co. (1970) to commemorate the Twelve Days of Christmas.

HAVILAND

Throughout history it has been the people with imagination, resourceful-ness and perseverance who exerted the greatest influence on the world. Often these people were inspired by chance encounters or accidents of fate.

David Haviland, the founder of Haviland & Co., was one of those people. In 1839, he was happily and successfully engaged in the importing of china. One day a customer wished a broken cup replaced, a not unusual request. However, Haviland was unable to identify the piece. There was no mark of any sort. He was baffled, since he was quite knowledgeable about china. To add to his bafflement, Haviland found the china to be the most beautiful he had ever seen. He was struck by its translucency and its pure white color.

His curiosity continued to haunt him. He decided he had to discover the source of this beautiful china. He went to France, an arduous voyage in the middle 1800s. His quest finally took him to Limoges, a city noted for fine china for over seventy-five years. There he found the match for his cup, and the reasons for its beauty.

Limoges had been chosen as the site for china manufacturing because of the abundance of kaolin, a pure white clay, to be found there. Though kaolin had been discovered in Limoges in 1764, the Chinese had known about it for centuries.

Haviland returned to America with the exclusive rights to import Limoges china. His elation was quite premature. It soon became apparent that his

venture was doomed to failure. Americans demanded decorated china, not the simple, unadorned china Haviland imported from Limoges. Though the French were adamant in their refusal to adapt to American tastes, Haviland persisted. Once he was convinced the French were not to be persuaded, he seized upon another alternative.

He decided to build his own factory in France.

Initially he encountered many difficulties. The veteran craftsmen in France refused to learn the new techniques of decorating and balked at Haviland's innovations. They heaped their scorn and anger upon the apprentices recruited by the new company. However, Haviland overcame all these obstacles, and by 1842 Americans were able to buy the new china.

The company built its American factory in 1936. The Limoges plant was refurbished shortly after World War II. Today the company manufactures the French-made products under the name Haviland Limoges while the domestic china is distributed through Haviland U.S.A. The modernization of the French factory enabled Haviland to perfect its production techniques. Electronically-controlled electric kilns and other technological advances reduced the prohibitive costs involved in manufacturing ornate china.

It is customary for each new President and his first lady to commission a new service of china. Haviland has frequently been chosen to produce the state dinnerware. In 1968, the company decided to reproduce in a limited edition a series of plates it had designed for various state occasions. The first plate, called the "Martha Washington Plate," was a copy made by the company in 1876. The 1876 plate was commissioned to celebrate the centenary of the signing of the Declaration of Independence. It was a replica of the china given to Mrs. Washington in 1796 by Andreas Everadus Van Braam Houckgust, a Dutchman and representative of the Dutch East India Company. It had been made in China on special order and the service was comprised of approximately forty-five pieces.

The plate's design is quite intricate. The border is a snake holding its tail in its mouth, a Chinese symbol of continuity: this represents the perpetuity of the Union. Within this border, there is a circular chain which contains the names of the fifteen states in the Union in 1796. The center of the plate features Martha Washington's monogram, which is set against a sunburst of gold, with the Latin motto, on a red scroll, "Decus Et Tutamen Ab Ille," (Honor and Protection Come From Him). There were 2,500 individually numbered plates issued at a price of $35.00.

In 1969, Haviland issued the Lincoln Plate, which is a replica of a luncheon plate from the White House service designed by Haviland & Co. of Limoges, France, for President and Mrs. Abraham Lincoln in 1861. Only a few pieces from the service survive and these are housed in the White House Collection of Presidential China in the Smithsonian Institution.

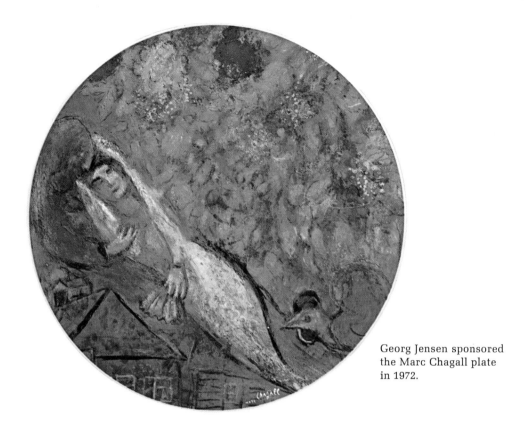

Georg Jensen sponsored the Marc Chagall plate in 1972.

"Wood Thrush," 1970 edition in Lenox's Edward Marshall Boehm series.

Royal Doulton's "Colette and
Child" by the renowned
American artist Edna Hibel.
1973.

The first Christmas plate by
Royal Copenhagen was made in
1908. Designed by Christian
Thomsen, it was entitled
"Maria with Child."

George Kuspert, the renowned German artist, has been the designer of Rosenthal's Christmas plate since 1964. His 1967 plate is entitled "Christmas in Regensburg."

"Mary and Child," Rosenthal's 1971 Studio Line Christmas plate designed by the famed Danish artist, Bjørn Wiinblad.

In 1972 Bjørn Wiinblad depicted Caspar the Moor, one of the Three Wise Men.

Melchior, another of the Three Wise Men was the subject of
Rosenthal's 1973 Studio Line Christmas plate.

"Golden Years," a three-
dimensional commemorative
plate designed by Antoneo
Borsato, the acclaimed sculptor
from Milan, Italy was introduced
by Intercontinental Fine
Arts Ltd.

Rosenthal's 1973 Christmas plate depicted "Christmas in Lübeck/Holstein."

"The Resurrection," a sterling silver and 24k gold plate designed by the acclaimed sculptor Evangelos Frudakis was the first Easter plate (1973) introduced by Franklin Mint.

The traditional crèche scene is depicted on Berta Hummel's Christmas plate for 1973.

"Jefferson Drafting the Declaration of Independence" is the title of the first (1973) of four commemorative plates produced by Franklin Mint at the request of the Bicentennial Council of the Thirteen Original States.

In 1974 the U.S. Historical Society issued a pair of French Limoges portrait plates depicting John and Polly Marshall.

"Two Turtle Doves,"
issued in 1971, is the
second in a series of
twelve.

In 1972, the third plate
depicts "Three French
Hens."

The center of the plate features the national emblem. A bald eagle is perched above the national shield amidst dark clouds and brilliant sunshine. The national motto, "E Pluribus Unum," is inscribed on a ribbon set below the emblem. A wide band in a purplish red color encircles the center's design. The union of the North and South is symbolized by the two entwining gold cables which rim the plate.

The Lincoln Plate had an original issue price of $100. The issue consisted of 2,500 individually numbered plates inscribed and signed by Theodore Haviland II. The inscription reads "Authentic reproduction of a plate of White House china made by Haviland at Limoges, France, in 1861 for President Abraham Lincoln and personally selected by Mary Todd Lincoln."

The Ulysses S. Grant Commemorative was issued in 1970, a century after the original 587-piece service was presented to the President and his first lady. The Grant service was often referred to as the "Flower Set," because reportedly a different American flower was depicted on the center of each

"Four Colly Birds," the fourth in the series of the Twelve Days of Christmas commemorated Christmas, 1973.

piece. William E. Walton created the original painting, which were adapted by Mr. M. Lissar, chief of the decorating department for the Haviland works in Limoges between the years 1868 and 1885. The service cost $3,000 in 1870. Two hundred and ninety one additional pieces were made in 1874 for the White House wedding of Nellie Grant, the President's daughter.

Haviland selected the "Wild Rose" plate for its Ulysses S. Grant Commemorative. The design is a deceptively simple one. A wild rose is set in the center of the white plate. A buff band encircles the floral design. In the border itself, in a medallion, is a small, accurate, and beautifully engraved rendering of the United States coat of arms. There are twenty-three shades of colors in the spray, a marvelous artistic achievement, given the technology of the 1870s.

Even with today's superior equipment, production of the plate is an arduous task. It requires forty-six days to proof—two days are required for each color.

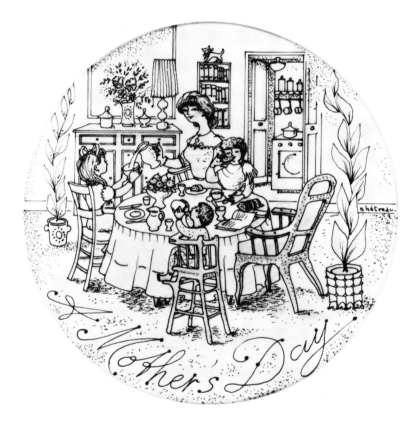

"Breakfast" (1973) the first in a series of seven plates produced by Haviland & Co. to celebrate Mother's Day.

Each plate was individually numbered, signed and inscribed by Theodore Haviland II in the following manner:

"Authentic reproduction of a plate of White House china made by Haviland at Limoges, France, for President Ulysses S. Grant and delivered on February 10, 1870. Limoges, February 10, 1970." The size of the edition was increased to 3,000 plates, but the issue price remained at $100.

The Hayes Plate was introduced in 1971. Haviland produced the White House Service for President Rutherford B. Hayes and his first lady in 1880. The Hayes china is considered the most elaborately conceived of any state service. It consisted of sixty-four different paintings on nine different shapes, ranging in size from individual butter plates to large meat platters. The designs on the plates form a record of the flora and fauna found in America in the late 1800s. Theodore R. Danis, the famed naturalist and watercolorist, was the artist.

One of the unique characteristics of the Hayes service was that the shape of the plate was frequently determined by its artistic theme. For example, the oyster plate, decorated with fine, beautifully painted bluepoint oysters and indented and ridged to receive the real oysters, has a roughened, almost serrated rim reminiscent of an authentic oyster shell. The three-dimensional shells on the plate are in a brilliantly colorful setting of seaweed, wrack and clusters of other shellfish, notably the raccoon oyster.

One of the unique features of the Hayes plates is the placement of the presidential seal. Traditionally, the seal appears on the front of the plates. However, Mrs. Hayes was so impressed with the artist's designs she felt the seal would be an intrusion on their beauty. Consequently, the seal is found on the back of the Hayes china. The back of the original china carried several other inscriptions. In addition to the red, white, and blue monogram of Theodore Danis interwoven with the numerals of the year he painted the set (1879), there is a special Haviland identification written in French, and inscribed in a bold, black signature is the statement, "the plate to be produced after the design of Theodore R. Danis." Two Haviland back stamps, one of which is intercepted by the Danis monogram, are also present. Further, the foot of the plate was banded in gold.

The 1971 plate also carried the following statement on its back.

> Authentic reproduction of the "Canvas Back Duck" design taken from the "Game Course" series of the White House china made by Haviland at Limoges, France, for President Rutherford B. Hayes and delivered on June 30, 1880.
>
> Limoges, June 30, 1971 (signed) *Theodore Haviland II*

The front of the plate shows the canvasback duck in flight over clusters

The Lincoln plate issued by Haviland & Co. in 1970 is a reproduction of a luncheon plate from the original service the company manufactured in 1861 for the White House during the Lincoln administration.

of cranberries. The coloration of the plates uses the contrast of mixed red cranberries in the foreground opposed to muted green-white waters and the canvasback duck itself, in brown and whites, is silhouetted against a grey and looming sky.

Two thousand five hundred plates were made for the Hayes issue at an original price of $110. Haviland intends to produce additional commemoratives for the administrations of Benjamin Harrison, Andrew Jackson and James H. Garfield.

Haviland inaugurated its series of Christmas plates in 1970. The series is based on the carol "The Twelve Days of Christmas."

"On the twelfth day of Christmas my true love gave to me twelve drummers drumming, eleven pipers piping, ten lords a-leaping, nine ladies dancing, eight maids a-milking, seven swans a-swimming, six geese a-laying, five golden rings, four calling birds, three French hens, two turtle doves and a partridge in a pear tree."

The Canvasback Duck Plate from the Game Service of the famous presidential china of the administration of President Rutherford B. Hayes, reissued by Haviland.

The back of the Hayes plate is unique. The presidential seal, normally on the front of the plate, was placed on the back at the request of Mrs. Hayes.

This beloved Christmas carol, began as a singing game, based on the old manner of celebrating Christmas. Years ago, the holidays began with Christmas and ended on January 6, the Feast of the Epiphany, sometimes called Little Christmas. The object of the game was to repeat the gifts given by the leader without making a mistake.

French artist Remy Hetreau was selected by Haviland to create the designs for the plates. There will be 30,000 pieces to each edition. "Partridge in a Pear Tree," the 1970 plate, and "Two Turtle Doves," the 1971 plate, were originally priced at $25. The price of the 1972 plate, "Three French Hens," was increased to $27.50 while the 1973 plate, Four Colly Birds, cost $28.50. It is interesting to note that the 1973 plate is entitled "Four Colly Birds," though the Christmas carol refers to them as calling birds. In the original fourteenth or fifteenth century singing game, it was the leader's intention to name the most difficult and improbable things to remember. The Colly (or

Coly), a native African bird, was as little known then as it is now. "Colly" is found in the original song.

In addition to the continuity provided by the theme, Haviland's Christmas plates always feature a house in the background of the central design. However, Hetreau creates a different house for each plate.

Along with many other companies, Haviland produces a series to commemorate the Bicentennial of the Independence of the United States. Remy Hetreau designed the five plates in the series:

> 1972—Burning of the *Gaspée*
> 1973—The Boston Tea Party
> 1974—The First Continental Congress
> 1975—The Ride of Paul Revere
> 1976—The Declaration of Independence

Each year 10,000 plates will be produced at a price of $39.95.

An annual Mother's Day plate was introduced in 1973. Haviland once again turned to Remy Hetreau to create the art. Mr. Hetreau, a Frenchman, designed a series of seven plates. The story behind the art work makes for a humorous ancedote. According to the company,

> It all began with a basic desire on the part of Haviland & Co. of Limoges, manufacturers of fine china for tables and collectors, to capture the unique quality of the French Fête des Mères—Mother's Day—with a single commemorative plate. Artist Remy Hetreau, who had collaborated with Haviland on previous successful collections—the Bicentennial of Independence Series and the Haviland Christmas Plates—responded with an exuberant burst of creative energy. He came to New York for a conference. The following ensued:
>
> Haviland: We are here to settle this matter of the Mother's Day plate.
> Hetreau: Yes, of course, Now, I would like to begin with "Breakfast."
> Haviland: "Breakfast?" I thought you might have had that on the plane. But, if you insist—
> Haviland: Now, we have had breakfast, what about the plate?
> Hetreau: Well, next, I contemplate "The Wash."
> Haviland: Really, these interruptions must stop.
> Hetreau: Then, I think "A Walk in the Park."
> Haviland: Remy, we a:e here to work. Sightseeing is on your own time.
> Hetreau: So I would proceed "To Market" for the next . . .

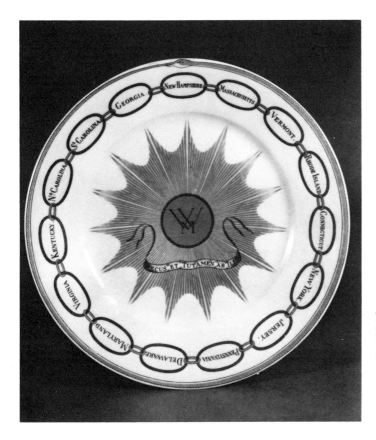

The Martha Washington plate, originally made in 1876, was reproduced by Haviland.

Haviland: Right. We are rushing to get the idea and sketch approved for an impressive presentation at the market. So, when do we begin?

Hetreau: I think "A Wash Before Dinner" would be the very next thing.

Haviland: Remy, we really must get down to work. First breakfast, then walking in the park, and now—knowing the market is so close—you talk about dinnner.

Hetreau: "An Evening at Home" would be charming.

Haviland: Remy. We have a Mother's Day plate to decide upon and you talk about visiting us tonight. Business first, please!

Haviland: Now, we envision the presents in the children's hands ...

Hetreau: Yes, the seventh plate will be the "Happy Mother's Day."

Haviland: What do you mean seventh? We ask for a single plate, and at last you have what we want.

Hetreau: Why just one plate? We have lived the day of a young mother—from breakfast to an Evening at Home.

Haviland: We have?

Hetreau: And we shall call it, The Haviland Series—"A Mother's Day."

Haviland: We will?

And, they did.

The Ulysses S. Grant Commemorative issued in 1970 by Haviland.

Haviland's 1976 Mother's Day plate, fourth in a series of
seven designed by French artist Remy Hetreau, is called "To Market."

The 1971 Svend Jensen Mother's Day plate.

SVEND JENSEN

One of the more recent Danish companies to enter the collector plate field is Svend Jensen. In 1970, Svend Jensen introduced its Christmas plate series as well as a Mother's Day collection. The porcelain plates are the familiar Danish blue and are made by the Desiree porcelain factory. The Christmas series is based on Hans Christian Andersen and his tales. The 1970 plate depicted his home, while subsequent plates recreated scenes from his stories:

 1970—Hans Christian Andersen's House.
 1971—The Little Match Girl.
 1972—The Little Mermaid.
 1973—The Fir Tree.
 1974—The Chimney Sweep.

The 1970 plate was a resounding success in the market. Originally issued at $14.50, it has reportedly become valued at several times its original price.

Svend Jensen's Mother's Day plates reflect the traditional themes of the holiday. The plates are seven inches in diameter, the same as the Christmas plates, and are also in the cobalt blue.

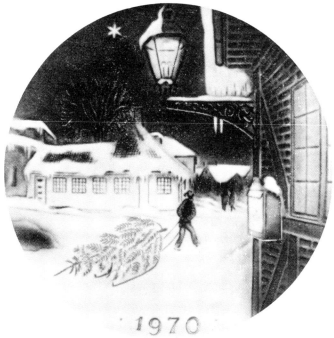

The Svend Jensen
Christmas plate for 1970
is entitled "The House of
Hans Christian Andersen."

"The Little Matchgirl," the
Hans Christian Andersen
fairy tale was the theme
for the 1971 Svend Jensen
Christmas plate.

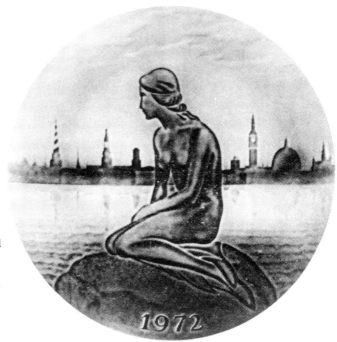

The famed "Little Mermaid" statue inspired by Hans Christian Andersen's tale is the subject of the 1972 Svend Jensen Christmas plate.

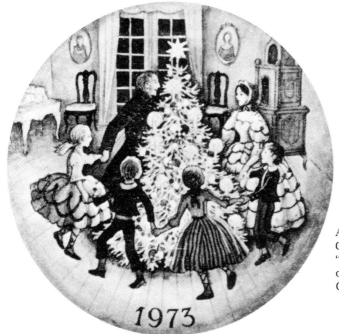

A scene from the Hans Christian Andersen story "The Fir Tree" is depicted on Svend Jensen's 1973 Christmas plate.

Svend Jensen's first
Mother's Day plate issued
in 1970.

Svend Jensen's 1972
Mother's Day plate.

The 1973 Svend Jensen
Mother's Day plate.

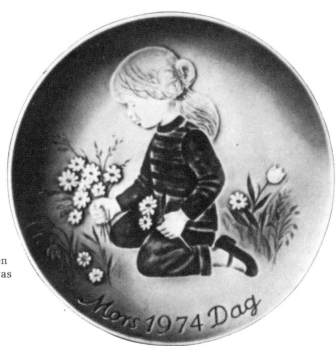

The 1974 Svend Jensen
Mother's Day plate was
entitled "Daisies for
Mother."

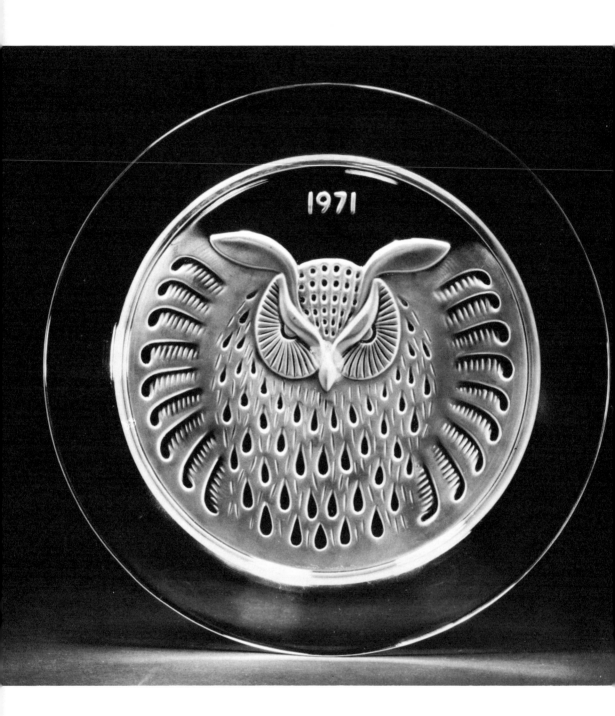

The Lalique annual plate, 1971.

LALIQUE

To plate enthusiasts, the name Lalique holds special meaning. For it was the Lalique annual plate, originally issued in 1965, which is generally given credit for initiating the tremendous interest in collector plates.

The founder of Lalique was René Lalique (1860-1945), a renowned artisan. Lalique gained his initial fame as a jewelry designer. In his early years he worked for Petitfils, an important jewelry firm in Paris. He experimented with plastics and other original ideas for jewelry. At Chez de Stape, then top jeweler in the world, he explored the use of enamels as a background for precious stones in place of the traditional rare metals. The effects he achieved revolutionized the jewelry trade.

By the time he was thirty, Lalique had started his own business, executing his own designs on a freelance basis. His clients included Cartier's and Sarah Bernhardt. His show at the Salon des Artistes Français was so well received that he numbered royalty among his new clients.

He continued to experiment with new materials. His attempts at using rock crystal for his designs caused him to consider glass as a medium. After a couple of false starts, he designed his own laboratory. In addition to the lab, Lalique designed a salon for displaying his works. The door for his new building was sculptured glass, and it represented his first architectural glass design. However, it was the perfume bottle he designed for the perfume Coty which won him acclaim.

Lalique's creations encompassed a wide range. He designed tableware, stemware, tumblers, pitchers, boudoir accessories, vases, and figurines. He also produced chandeliers, lamps, clocks, and ashtrays. He did not confine his talents to household articles. His artistry found inspiration in a vast number of other areas, including doors, mantels, gates, windows, fountains and pavilions. Churches were a main beneficiary of Lalique's talent. He created complete altars as well as crucifixes, madonnas, etc. He even designed a crystal eagle radiator ornament for the Deslages car.

Though Lalique died in 1945, his son and granddaughter have proven worthy to carry on his work. It was Marie-Claude Lalique who designed the annual plate of 1965. The annual plates are eight and a half inches in diameter and are signed in script "Lalique, France" and dated. The Lalique plates are truly a limited edition. The 1965 plate entitled Deux Oiseaux (Two Birds) numbered only 2,000. The 1966 edition was somewhat larger, but no edition will number more than 5,000 plates.

The Lalique plates are sold only in the United States. The 1965 plate has become a sought-after collector's item, commanding a price many times over its original value.

The Lalique annual plate, 1967.

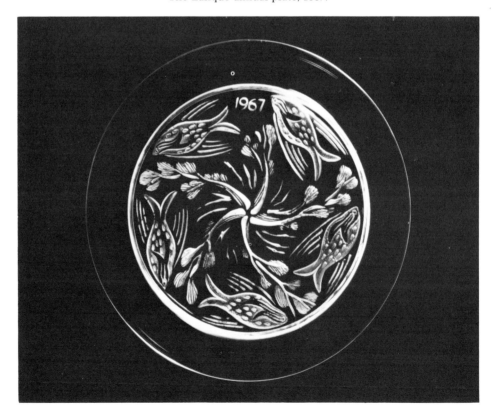

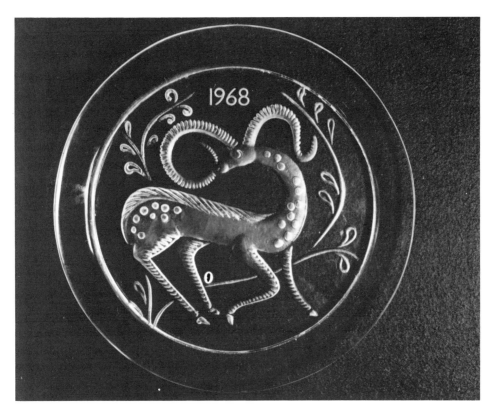

The Lalique annual plate, 1968.

The Lalique annual plate, 1969.

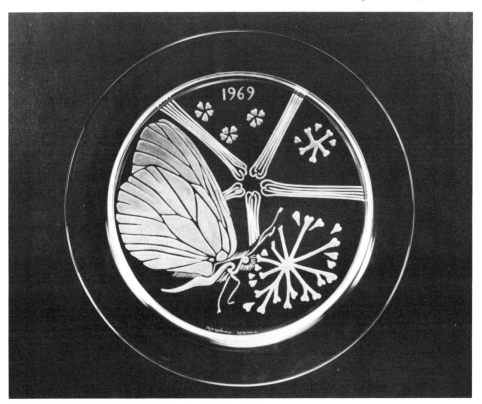

The Lalique annual plate, 1970.

The Lalique annual plate, 1972.

The Lalique annual plate,
1973.

"The Raccoons," the first plate in Lenox's Woodland Wildlife Series by Edward Marshall Boehm, was issued in 1973.

LEOTA L. MONGAR

May 12, 1897
Des Moines, Iowa

January 26, 1987
Polk City, Iowa

Services
January 29, 1987
Highland Park Funeral Home
Des Moines, Iowa

James Robertson, Pastor
Highland Park Christian Church

Organist
Mrs. Mildred Lamb
"In The Garden"
"The Old Rugged Cross"

Bearers

Tom Thompson	Linn Coellner
Paul Coellner	Randy Baird
Tom Coellner	Timothy Shields
Michael Wilson	

Interment
Highland Memory Gardens
Des Moines, Iowa

God hath not promised
　　Skies always blue,
Flower-strewn pathways
　All our lives through;
God hath not promised
　　Sun without rain,
Joy without sorrow,
　Peace without pain.

But God hath promised
　Strength for the day,
Rest for the labor,
　　Light for the way.
Grace for the trials,
　　Help from above,
Unfailing sympathy
　Undying love . . .

LENOX

In some respects, the story behind the Lenox China Co. reads like a soap opera. Its founder, Walter Scott Lenox, overcame poverty, prejudice, blindness, paralysis, and even an earthquake before he saw his company attain success.

When Lenox established his company in the late 1800s, America was in the throes of its love affair with things European. And rightfully so, for the country had yet to develop the skilled craftsmen needed to produce beautiful objects like fine china. Lenox was convinced that an American company could duplicate and even surpass its European counterparts. However, his struggle was an arduous one.

Often using borrowed funds, Lenox experimented and explored various techniques for making fine china. He decided to make Belleek, a rich ivory-tinted china, so named for its origin, Belleek, Ireland. His attempts to perfect the required production techniques were marked by frustration. Foreign potters were imported and ancient methods were researched. Lenox finally succeeded in developing his own formula.

After the production difficulties were solved, the company still had to overcome America's prejudice against domestic china. Lenox persevered and eventually he persuaded Shreve & Co. of San Francisco to book a substantial order. Lenox's elation was destined to be shortlived. The china arrived in San Francisco, but so did the city's famed earthquake and fire.

But for once, the adage "From the ashes of defeat . . ." proved to be literally as well as figuratively true. Amidst the wreckage of the disaster, a Lenox plate was discovered. Despite the catastrophe, the plate itself survived. Its beauty had been marred by smoke and little of its ornate design remained. But the durability of the china had been proved. The blackened plate became a feature of Lenox's sale campaign.

Eventually, the company's efforts were rewarded. Tiffany's, New York's most prestigious shop, agreed to carry Lenox china. Although many other fine stores in New York and Philadelphia followed Tiffany's lead, Lenox still had not gained public recognition. Domestic china was still considered inferior to European ware.

However, the company gained instant renown in 1917 when Woodrow Wilson requested Lenox to make the White House china. The service was called "Command Performance" and its beauty and durability (only four of the 1700 pieces were broken during Wilson's administration) impressed

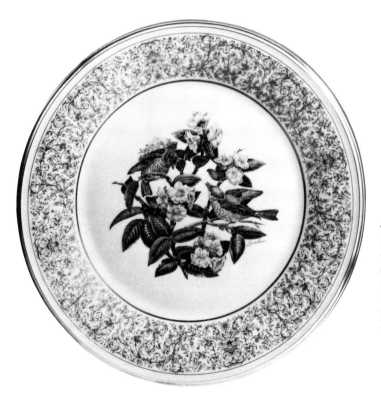

The first collector plate produced by Lenox China was issued in 1970. It depicted the Wood Thrush and was a reproduction of a work by a noted sculptor, the late Edward Marshall Boehm.

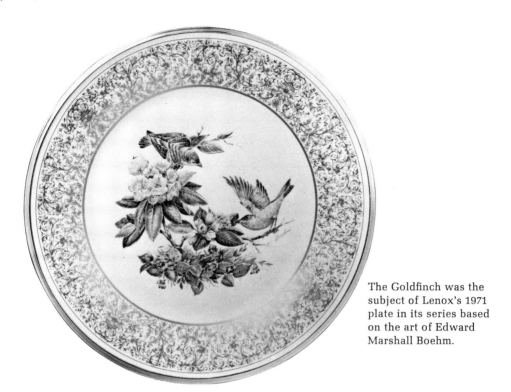

The Goldfinch was the subject of Lenox's 1971 plate in its series based on the art of Edward Marshall Boehm.

hard-to-please Washington society. Command Performance remained popular with other Presidents. Both Franklin D. Roosevelt and Harry S. Truman chose the elegant gold and teal green service for their official White House service.

Through the years Lenox has retained its reputation as a manufacturer of distinction. The Metropolitan Museum of Art in New York honored the company by commissioning a service of Command Performance for a special exhibit. Lenox also received unique recognition from the Ceramic Museum in Sèvres, France. A coffee set by Lenox is on exhibit, the only American china represented.

Lenox has also been a leader in the merchandising area. It pioneered the "place setting" concept, which enables customers to purchase fine china over a period of time. This innovation opened the market for fine china to consumers who previously had been unable to afford a full service.

In 1970, Lenox introduced a service of limited edition plates based on

the work of the late Edward Marshall Boehm, the acclaimed naturalist, sculptor and artist.

The series has been enormously successful. Lenox's reputation for excellence, combined with Boehm's renown evoked a tremendous response from plate collectors. The 1970 plate retailed for $35, but it has reportedly commanded up to eight times its original price.

The Lenox-Boehm plates are produced in vivid color with an intricately designed border of 24k gold. The series began with the Wood Thrush in 1970 and continued with:

1971—The Goldfinch 1974—The Rufus Hummingbird
1972—Mountain Bluebird 1975—American Red Start
1973—Meadowlark 1976—Cardinal

The Boehm feather hallmark appears on the back of each plate and the Boehm signature on the front.

Lenox offers another series of plates, the Woodland Wildlife Series, introduced in 1973. They too are reproductions of works by Edward Marshall Boehm.

"The Foxes" was issued in 1974 and is the second plate in Lenox's Woodland Wildlife Series by Edward Marshall Boehm.

The 1972 Lenox plate is its series based on the work of Edward
Marshall Boehm depicted the Mountain Bluebird.

The 1972 Jean Paul Loup Christmas plate was limited to an edition of 500 plates.

JEAN PAUL LOUP/ BETOURNE STUDIOS

The Betourne Studios in Limoges, France, manufacture by hand true enamel-on-copper plate classics using a centuries-old method developed in the 1500s by renowned enamel master Leonard Limosin.

Almost all the studio's plates, which are distributed by Jean Paul Loup, the editor of *Art Limited Editions* in River Forest, Illinois, are purchased by American collectors.

The studio was founded around the turn of the century by Raphael Betourne. His two sons, Jean and Michel, continue their father's tradition of flawless quality. The studio achieved a classic elegance similar to the old masters of the delicate Champleve technique with its 1974 Mother's Day plate.

The plate, in a 500-copy limited edition, took three years of research and thirty-five enamellers to produce. Because of high production costs, it was the last to be made in the technique.

The Champleve method is exceedingly intricate. The design is outlined by the artist on a copper plate about an eighth of an inch thick.

The plate is dipped in acid several times to etch the parts to be enameled. The etching is completed using a steel needle. The cavities are then filled with a semi-opaque enamel after which the plate is fired repeatedly to eliminate bubbles. Since the enamel shrinks during firing, it must be reapplied.

147

Excess enamel is removed from the copper walls which form the design by rubbing it with stone.

The last step is a bath in a gold solution, which gives the plate a solid gold appearance.

The Christmas plate series, initiated in 1971, is produced using the classic enamelling technique. The first edition numbered only 300 plates, and it has sold for more than ten times its original issue price of $150. The subsequent editions were increased to 500. They too have enjoyed enormous popularity and have increased in value.

The studio's 1975 Mother's Day edition was created in classic enamel, according to Loup, not the Champleve method.

The Jean Paul Loup Christmas Plate for 1971 had a limited edition of 300.

Jean Paul Loup's 1973 Christmas plate is completely hand done, as are all the works produced by this firm.

The 1974 Christmas plate by Jean Paul Loup.

Jean Paul Loup introduced its first Mother's Day plate in 1974. The Champleve Method is a highly complex process which requires 112 hours for each plate.

The Navajo Christmas plate for 1972 produced by the Kay Mallek
Studio in Tucson, Arizona.

KAY MALLEK STUDIOS

The Kay Mallek Studio in Tucson, Arizona, inaugurated its Navajo Christmas plate series in 1971. The first plate depicted the traditional scene of the Three Wise Men bearing gifts. However, the artist, Robert Chee, a young Navajo artist, used his own heritage in his art. The Wise Men are Indians and their gifts are lamb, corn, and pottery. In addition to the Star of Bethlehem, the scene shows the Rainbow God hovering over the Indian Wise Men. In Indian lore, the Rainbow God is revered as the protector, holding all good things close to the earth.

This plate represented a unique offering in the plate collecting field. It was the first plate designed by an Indian artist. Only a thousand plates were issued and the plate's popularity increased enormously when news of the artist's death became known. Robert Chee, whose Navajo name was Haskke-yil-e-dale, meaning the Angry One, died in November, 1971, at the age of thirty-six. His talent emerged early in his life. In his childhood he enjoyed painting with charcoal on the rich red cliffs. He went on to study art with the noted Apache artist John Houser. While in the Army, he was stationed in Germany, where he painted murals on Army buildings.

The 1971 plate, which was originally issued for $17.00, has commanded $185 on at least three occasions. It continues to be in great demand and sells for several times its original issue price.

Andy Tsihnahjinnie designed the 1972 Navajo Christmas Plate. He com-

153

memorated Christmas on the reservation. The Indian family, the father astride his horse, the mother holding her baby, and the child embracing his dog are shown with the Rainbow God over their heads and the Star of Bethlehem in the background. Mr. Tsihnahjinnie has received much acclaim for his paintings and examples of his work can be found in many museums.

A young Navajo boy and girl feeding the birds and animals and tending to their pet lamb is the subject of the 1973 plate designed by Hoke Demetsosie. The Star of Bethlehem and the Indian Rainbow God are once again symbols of the religious motif.

The Kay Mallek Studio produced several other series of plates, including a Mexican Christmas (Navidad) plate series. It was introduced in 1972 and designed by Debbie Jensen, a young artist noted for her paintings on porcelain tile. The traditional Nativity scene was the subject of the 1972 plate. However, the ethnic flavor is beautifully captured by the artist.

The 1973 issue was designed by Jack Schwanke, noted for his Mexican and Indian paintings. "Navidad en Mexico, 1973," shows Mary on a burro accompanied by Joseph in a sombrero and several Mexican children.

The Navajo Christmas plate for 1973 designed by Hoke Denetsosie.

Kay Mallek Studio introduced its Mexican Christmas plate series in 1972.

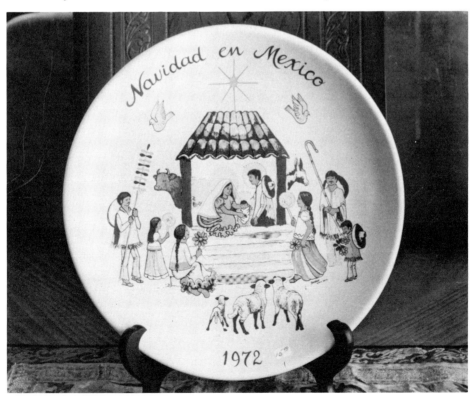

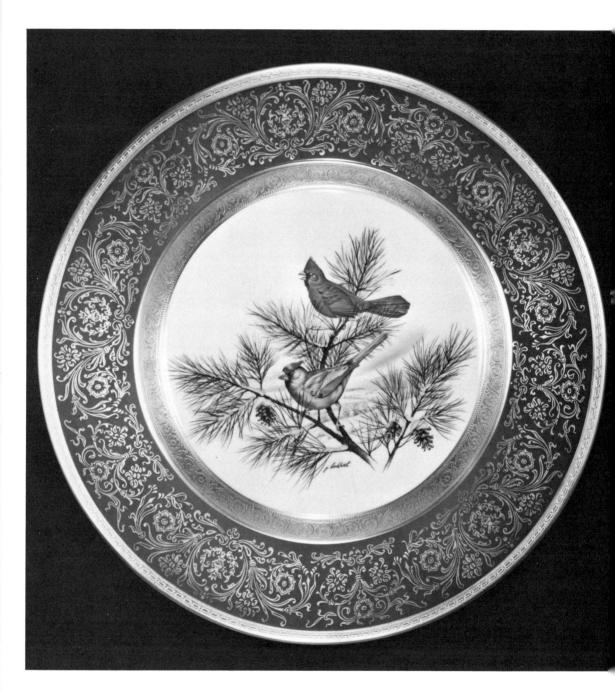

Pickard introduced its Lockart Birds Series in 1970. The first plate depicted
Game Birds: Ruffed Grouse and Woodcock.

PICKARD

Wilder Austen Pickard established the Pickard China Studio in 1898. He had developed an interest in china manufacturing while working as a china salesman. His first ventures into the field of production were on a very small scale. He supplied plain white china for talented artists to paint. These early activities were quite successful, and Pickard China Studio was formally founded with a staff of artists from the Chicago Art Institute. By 1904 the company had expanded to a staff of fifty artists and a new studio was built.

It was Pickard's desire to see the art of china painting receive the aesthetic recognition he felt it deserved. The company's policies were geared toward achieving this end. Time and cost were not major factors at Pickard. For instance, the company frequently chose 24k gold, sometimes referred to as "honey gold," for its designs. The honey gold technique, allegedly discovered in the eighteenth century, required that gold leaf be combined with honey during the firing process, the honey burned away leaving the heavy, raised, encrusted gold.

Pickard began producing his own china in 1935. All the people who participated in the creation of the first set of china signed the first plate in gold. In 1925, the company incorporated and chose the lion with fleur-de-lis as its first trademark.

The company is still headed by a Pickard and remains the only fine china

company in the United States still under one-family ownership since its inception.

In 1970, Pickard selected the wildlife paintings of noted American artist James Lochart as the designs for a series of eight limited edition service plates. The plates are 10⅝ inches in diameter and feature an intricate gold design on a rich green background on the shoulders. The edge and the verge are etched in gold. The edition numbered 2,000, and the initial price for the pair of plates was $150.

The 1970 plates were entitled Upland Game Birds and illustrated the Woodcock and the Ruffled Grouse. The 1971 subject was waterfowl—the Mallard and Green Wing Teal. Songbirds were chosen for the 1972 plates, with the Mockingbird and Cardinal depicted. In 1973, the series portrayed two other game birds, Wild Turkey and Ring-necked Pheasant. The issue price for the plates had increased to $165 by the 1972 edition.

The Pickard Presidential Series was started in 1971 with the Truman plate.

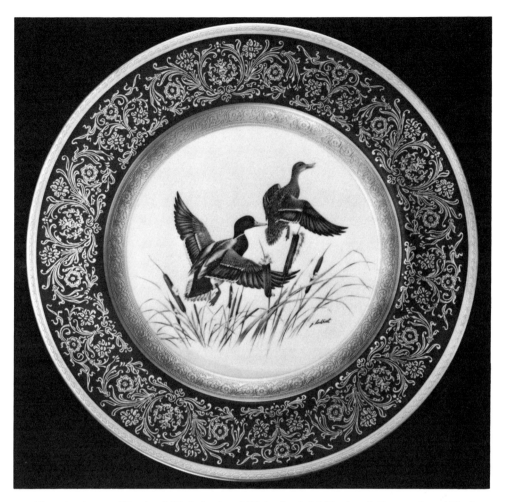

The 1971 issue of Lockard Birds featured Waterfowl: Mallard and Green-winged Teal.

In 1971, Pickard inaugurated its Presidential plate series with its Truman plate. The plate had a green border, gold scroll and trim, and sepia portrait of Mr. Truman. The issue price was $35 and the edition was limited to 3,000 plates. The first fifty plates were numbered. Plate #1 was presented to Mrs. Harry S Truman, #2 was retained by Pickard for its collection, #3 went to Mrs. Margaret Daniel (Mrs. Truman's daughter) and #4 to the Truman Library.

The second plate in the series, the Lincoln plate, was introduced in 1973. It had a cobalt blue border, gold scroll and trim, and a charcoal gray image. The issue price remained at $35.00, but the size of the edition was increased to 5,000 plates.

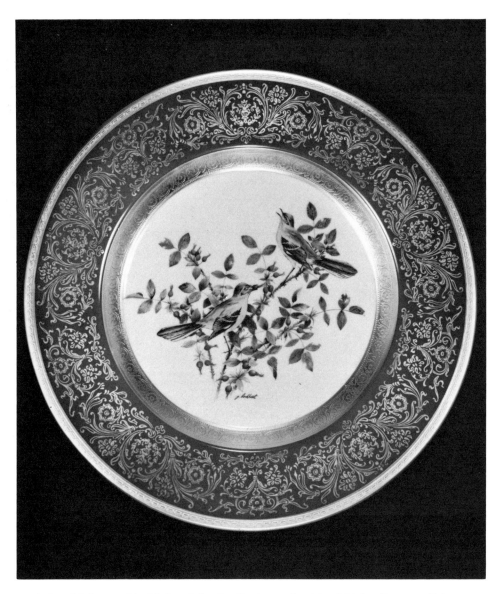

Songbirds: Mockingbird and the Cardinal was the title of Pickard's 1972 edition of Lockart Birds.

In 1973, the series was completed with Game Birds: the Wild Turkey
and Ringnecked Pheasant.

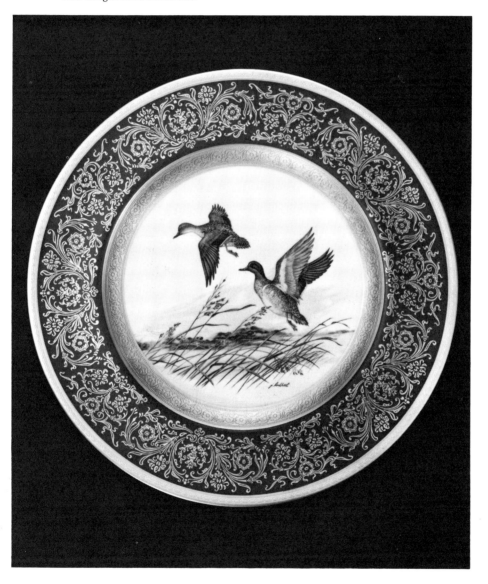

The 1973 Christmas plate issued by Porsgrund depicts the angel apearing to Mary.

PORSGRUND

Unlike its neighbor, Denmark, Norway does not boast of many porcelain factories. However, Norway's first and only porcelain manufactory ranks among the best. The company was founded in 1885 by Joban Jermiassen, who had come to know the town of Porsgrund through his wife, a native. His decision to establish a porcelain factory was based on his awareness that the area was rich in the raw materials needed to produce good porcelain. German companies had been importing the materials for years.

In the formative years of the company it did little to encourage the use of original Norwegian designs. Instead it relied on basic European concepts and forms. However, by 1920 the company had appointed Hans Flygenring, a famed Danish painter and sculptor, to develop and encourage new designs more in line with the Norwegian style of art.

Currently the company produces four series of collector plates. In 1968, the company resumed making a Christmas plate—Porsgrund had been one of the first porcelain factories to make a Christmas plate, in 1909. However, unlike Bing and Grøndahl and Royal Copenhagen, it didn't continue the practice.

In 1970, the company began its series of Deluxe Christmas Plates. As its name implies, the Deluxe Series feature bigger and more ornate plates. However, the designs found in the traditional series are maintained for the more elaborate plate.

Porsgrund also produces a series of annual plates for Mother's Day and Father's Day. The former began in 1970, while the Father's Day series was introduced in 1971.

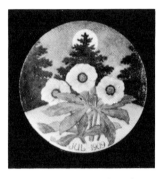

Porsgrund introduced its first Christmas plate in 1909.

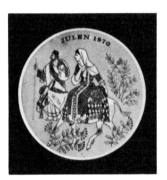

Mary and Joseph on the way to Bethlehem is the scene depicted on the 1970 Christmas plate by Porsgrund.

Angels were the central characters in Porsgrund's 1972 Christmas plate, to illustrate the theme "Hark the Herald Angels Sing."

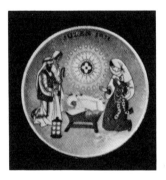

Porsgrund's 1971 Christmas plate depicted the Infant Jesus.

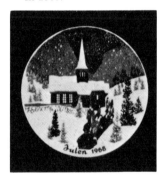

Porsgrund resumed making an annual Christmas plate in 1968.

"The Three Wise Men" is the subject for Porsgrund's 1969 Christmas plate.

Porsgrund's deluxe
Christmas plate series,
introduced in 1970, is a
bigger, more ornate
version of its traditional
Christmas plate. The
design remains the same.
The 1973 deluxe
Christmas plate.

The 1973 Mother's Day
plate, fourth in
Porsgrund's annual series.

Tapeo Wiarkkala was chosen to design the 1972 plate, which introduced a new limited series for Rosenthal called simply Year Plate 1972.

ROSENTHAL

Though the name of Rosenthal is a revered one in the world of porcelain, the company is a comparatively young one. Unlike some of its competitors, Rosenthal is not centuries old. It was founded in 1879 by Dr. Philip Rosenthal, a member of a third generation of Westphalian potters and china traders. Mr. Rosenthal resisted his heritage for several years. At the age of seventeen, he ran away to America. For three years he was a cowboy in Texas. Eventually, he became a buyer of chinaware for a Detroit store. When he returned to Germany he established his factory in an old castle near what is now the German border with Czechoslovakia. With one helper, he began the business of porcelain making. He is credited with initiating the practice of signing the pieces. All his products bore the name Rosenthal. Mr. Rosenthal, who sometimes attributed his success to a combination of American merchandising methods and German craftsmanship, chose a distinctive signature. The Rosenthal marks are a crown over crossed roses with "Rosenthal" beneath a crown with "R.C." arranged in crossed diagonals.

The company has been producing Christmas plates since the early 1900s, though there is little certitude as to the exact year. Records have been lost and opinions differ. Some say 1908, while others maintain the first plate did not appear until 1910. However, a Christmas plate has been produced every year since 1910. The plates are made of hard paste porcelain and are approximately eight and a half inches in diameter. With the exception of

the inscription "Weihnachten," which is a done in overglaze, the plates are hand-painted and decorated in the underglaze method. Similar to many of the other Christmas plates, the Rosenthal Christmas Plates are predominantly blue, though tints of green, brown, and yellow are sometimes included. Later plates have narrow white and gold edging, while the earlier ones featured white borders.

Most of the designs were commissioned, but some of the plates have designs taken from old prints or lithographs. On occasion the company has sponsored special competitions for artists and the winning design is the subject for the plate. The name of the artist is always found on the back of the plate; some plates show the initials of the artist on the face of the plate.

Before 1970, the company made it a policy to provide open stock on its Christmas plates. In effect, that meant production of a given plate never ceased. To some collectors this policy reduced the value of the Rosenthal plates, since they were not truly a limited edition. However, it should be noted that Rosenthal's editions were always quite small compared with some of their competitors. The 1967 edition numbered only 7,000 plates, while the 1968 and 1969 editions totalled only 8,000 each. Molds for the early plates have long ago disappeared, so it is impossible to reproduce the early plates. The company's policy of producing a plate on order was probably more of a service and courtesy feature than a business decision. The process of making the plates is an involved and costly one and skilled artisans are difficult to obtain.

The 1971 Christmas plate was the first one under the new policy of limited editions. All the molds for previous Christmas plates were destroyed and only 10,000 Christmas plates were issued in 1971.

In 1971, Rosenthal introduced a Studio Line Christmas Plate. The first three plates were designed by Bjørn Winblad, an acclaimed Danish artist. The 1971 plate was "Mary and Child" and in 1972 the theme of the Three Wise Men was begun. The 1972 plate featured Caspar the Moor, 1973 depicted Melchior, 1974 had Balthazar as the subject. Each plate is eleven and a half inches in diameter and is decorated in sixteen to eighteen colors and two shades of 18k gold. The unusual shape of the plate requires a unique production technique. It is an extremely flat-rimmed plate. Consequently, it must be fired in a bed of sand to prevent its warping during the firing process. The back of the plate is never glazed but is polished to fineness after the firing is completed. The plates were limited to an edition of 4,000 in the United States and retailed for approximately $100.

Rosenthal also began a series of annual plates in 1971 which is quite unusual. The designs of the plates reflect the latest trends in the contemporary art world. The first plate was designed by Tapeo Wirkkala, the second by Natale Sapone, the third by Otto Piene.

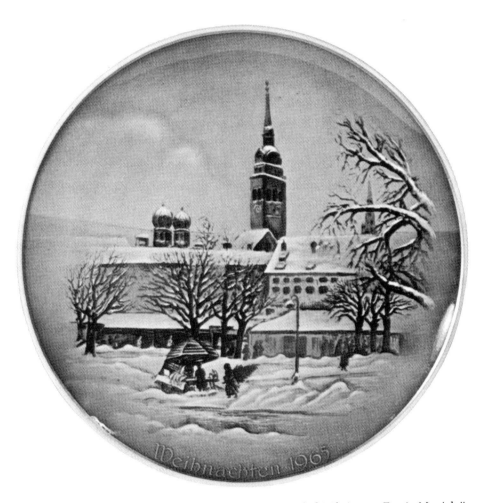

Rosenthal's traditional Christmas plate of 1965 is entitled "Christmas Eve in Munich."

Sapone, an Italian painter and sculptor, is noted for his constructive systems concept which is based on a circle and extends to the third dimension. His design for the 1972 plate is a series of undulating lines intertwined. The plate had a limited edition of 3,000 worldwide, with a hundred specified for the United States.

Otto Piene, a kinetic sculptor and professor of environmental art in Cambridge, Mass., designed the 1973 plate. With Mach and Uechek, Mr. Piene founded the Group Zero, a major influence on contemporary art. At the Olympic Games in Munich, he took first prize in the Olympic Art Competition. He designed light satellites at the Olympic grounds as well as the Olympic rainbow presented at the opening and closing ceremonies. Piene selected the rainbow as the subject for his design. To him it is a symbol of survival which man, despite his onslaught on the environment, has not yet attacked. Three thousand signed and numbered plates comprised the entire edition, with two hundred allocated to the United States.

Otto Prene, the artist for Rosenthal's 1973 plate, chose the rainbow for his theme.

The second plate in Val. St. Lambert's American Heritage Series issued in 1970 commemorated Paul Revere's Ride.

VAL ST. LAMBERT

Val St. Lambert enjoys worldwide acclaim for the beauty and artistry of its crystal works. The firm is located in Belgium and takes its name from the site of its original factory. In 1825 two gentlemen, Kemlin and Lebrevre, chose to found their factory in Liege, Belgium, the center of artistic glass-making in the seventeenth and eighteenth centuries. The factory was housed in an old abbey which dated back to the latter part of the twelfth century. In 1202, monks had renamed the abbey Val-Saint-Lambert (Valley of Saint Lambert) to honor the founder of Liege.

Through the years, Val St. Lambert conducted experiments and sponsored research for the purpose of developing new methods of crystalmaking. Much of the work in the manufacture of crystal must be done by hand. The ancient art of glass-blowing remains a difficult one to master. A skilled artisan often spends ten to twelve years perfecting the required techniques.

Val St. Lambert introduced its Old Masters Series in 1968. A pair of intaglio engraved eight-inch plates were issued annually, honoring two artists. The issue was limited to 5,000 pairs and retailed for $50.00 per set. Each plate was hand-inscribed "Edition Limited, Val St. Lambert." The 1968 artists were Rubens and Rembrandt, 1969, Van Dyke and Van Gogh; 1970, Michelangelo and Da Vinci; 1971, Goya and El Greco; and the final issue in 1972 featured Gainsborough and Reynolds.

The reception accorded the Old Masters Series prompted the company

to inaugurate its American Heritage Series. The plates in the new series were thirteen inches in diameter, hand engraved, numbered and signed. The edition was limited to 500 pieces and the first two plates in the series, "Pilgrim Family" and "Paul Revere's Ride" were issued at $200. The third plate in the series, "Washington Crossing the Delaware," retailed for $225.

The second edition (1969) of Val St. Lambert's Old Masters Series featured Van Gogh and Van Dyke.

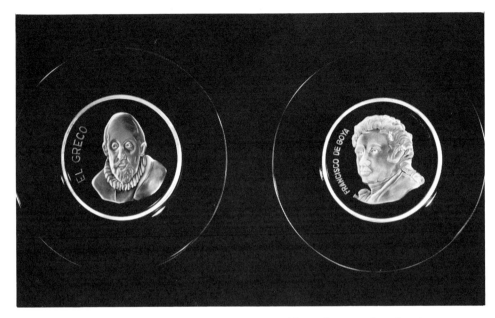

El Greco and Goya were the artists selected by Val St. Lambert for the 1970 issue of the Old Masters Series.

Val St. Lambert introduced its Old Masters Series in 1968. Rubens and Rembrandt were the subjects of the first two plates.

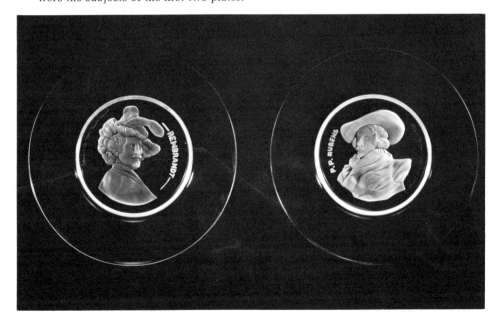

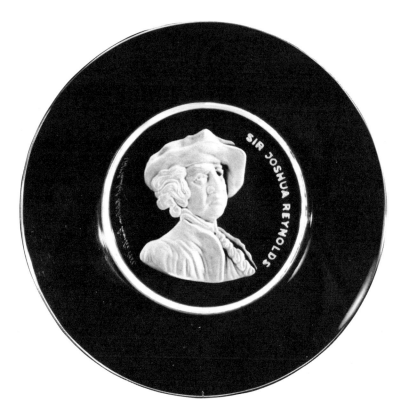

In 1972, Gainsborough and Reynolds were depicted on the plates in Val St. Lambert's Old Masters Series.

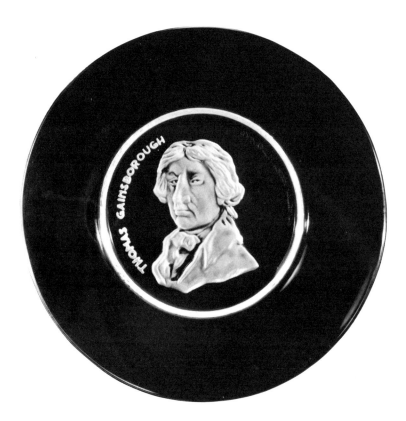

"Pilgrim Family," issued in 1969, was the title of the first plate in Val St. Lambert's American Heritage Series.

Berta Hummel's 1972 Christmas plate was entitled "Engel mit Flöte."
("Angel with Flute")

SCHMID BROTHERS
BERTA HUMMEL SERIES

In 1971 this West German firm was granted the sole authority to produce plates based on the paintings and sketches of Berta Hummel, an artist born near Oberammergau, Bavaria, who became a nun in 1924. As Sister Innocentia in the Convent of Siessen in Bavaria, she devoted herself to the religious life. Her love of humanity was expressed in her art. She died in 1946.

In 1972, Schmid Brothers, with the exclusive approval of Mrs. Victoria Hummel, the mother and legal heir of Sister Innocentia, presented a work entitled "Playing Hookey." The plate retailed for $15.00, and sold out almost immediately. The work was based upon a story related to the artist by her brother, Dr. Franz Hummel, about a harmless youthful escapade.

That same year the firm also produced a Christmas plate entitled "Angel with Flute." It was reproduced from an oil painting which the artist had given to her sister, Mrs. Kathe Edenhofer.

In 1973 Schmid Brothers was granted the exclusive right to the Berta Hummel crèche scene. It became the subject of the 1973 Christmas plate. It marked the first time the design had been made public. The plate retailed for $15.00.

The 1974 Christmas plate by Berta Hummel for Schmid Brothers is entitled "Guardian Angel."

"Playing Hookey" was the subject of the 1972 Mother's Day plate by Berta Hummel for Schmid Brothers.

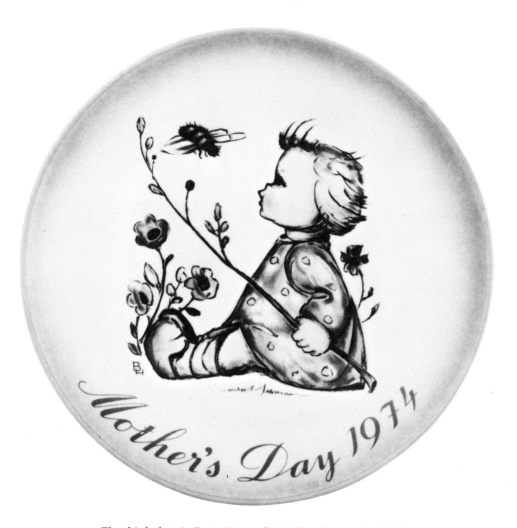

The third plate in Berta Hummel's Mother Day series. (1974)

Wallace Silversmith and the noted German sculptor Gunther Granget
collaborated for the 1973 spring plate.

WALLACE SILVERSMITHS

Wallace Silversmiths was founded in 1835, and within one year it had established itself as an innovator. In 1836, the company replaced pewter with the new alloy, "German Silver." Throughout its history, the company has maintained its reputation for creating revolutionary designs. In 1934, Wallace introduced the first raised design in sterling silver. Grande Baroque, one of the early patterns that featured the three-dimensional concept in its design, remains to this day one of the most popular patterns in the industry.

Wallace began manufacturing silver flatware in 1875. By 1892, the company's activities expanded to include the production of all types of flatware, hollow ware, and the abundance of other articles in which silver was a component. The company continued to grow and in 1945, Wallace acquired the Watson Company, Tuttle Silversmiths, and the Smith and Smith Company.

The import firm of Paul A. Straud & Co., Inc. was acquired in 1969. Straud's imports included the porcelain dinnerware and figurines by Hutschenreuther of Germany, and fine crystal stemware and hollow ware from Austria, Germany, Norway and Japan.

With the acquisition of Hutschenreuther, it was natural for Wallace to consider entering the collector plate field. In 1972, the company inaugurated a series entitled "Songbirds of America" featuring the wildlife art of John A. Ruthnen. Mr. Ruthnen has won international recognition and acclaim for

his wildlife paintings. His works are in considerable demand and have been exhibited at numerous shows throughout the U.S.

The first pair of plates in the series depicted the Eastern Bluebird and Goldfinch. The edition was limited to 5,000 for each plate and all were signed and numbered by the artist.

The Robin and the Mockingbird were the subjects of the 1973 edition. The issue price for the two editions are somewhat different. The 1972 plates were issued at $150, which included a wooden case. In 1973, the plates could have been purchased for $100 without the case.

Gunther Granget, associated with Hutchenreuther from 1953 to 1970, designed the 1973 spring plate for Wallace Silversmiths. The ten-and-an-eighth-inch plate is created in bas-relief on bisque porcelain. The plate, done in tones of blue and brown, depicts a mother killdeer with her young on the banks of a tranquil lake. Each plate bears the artist's signature and had an original issue price of $75.

The spring plate was the second one designed by Granget. His first was the 1972 Christmas plate for Wallace Silversmiths. The plate depicted a family of sparrows nestled on a branch. The Christmas plate was similar to the spring plate. It too measured ten and an eighth inches and was done in bas-relief on bisque porcelain. However, the issue price for the Christmas plate was $50.00.

Mr. Granget is a noted sculptor whose works are known throughout the world. His most famous work is a limited edition porcelain sculpture of dolphins in motion. He is also noted for the ten-figure series, "Birds of Forest, Field and Stream," done in bisque porcelain. Mr. Granget's skill is not limited to porcelain, however. He has been commissioned by Wallace to execute a series of animal figurines in sterling silver. It will be the first time he has worked with silver.

Granget, who also produces wood carvings, recently completed the first piece in a series of naturalistic sculpture to be executed in lead crystal.

The 1973 edition of Wallace Silversmith's "Songbirds of America," by John A. Ruthnen, featured the Robin and the Mockingbird.

The 1972 Gunther Granget plate distributed by Wallace Silversmiths
of Wallingford, Conn.

The wildlife art of John A. Ruthnen was reproduced on porcelain for Wallace Silversmiths. The series entitled "Songbirds of America" was begun in 1972 with a pair of plates—Eastern Bluebird and the Goldfinch.

"The Rites of Spring" by Pablo Picasso was the second in the Modern Masters Series of Collector plates originated by the George Washington Mint and perpetuated by Medallic Art Co.

GEORGE WASHINGTON
MINT AND MEDALLIC ART

The George Washington Mint was founded in 1972 by Reese Palley, known for his merchandising expertise and knowledge of Boehm porcelain. In accordance with Palley's long-held beliefs about the concept of "limited editions," the George Washington Mint announced the size of its editions.

The editions were also relatively small, numbering about 10,000 and each plate was numbered. An internationally known artist was selected for each issue.

Four plates were issued in 1972. The N. C. Wyeth Americana Series was inaugurated. "Uncle Sam—The Arsenal of Democracy," was the first plate, the eight-inch plate was done in full bas-relief and was made of solid silver. Over ten ounces of silver were used. The edition was limited to 9,800 pieces, with all of the plates individually numbered. The Wyeth plate was issued at $150, as were almost all the plates produced by the company.

The Great Modern Masters Series featured Pablo Picasso's "Don Quixote de la Mancha" as its first subject. The eight-inch plate bore the artist's authorized signature. There were 9,800 plates made of silver, 100 of 18k gold, and another 100 were foundry specimens of special patina. The plate represents the only one authorized by the late artist.

A portrait in silver of "Whistler's Mother" was another plate issued in 1972. The plate commemorated the 100th anniversary of the painting. There was 10,000 individually numbered plates in the edition. The full bas-relief plate contained ten ounces of sterling silver.

A series of plates depicting scenes of the American West was also begun in 1972. The first plate featured the portrait of "Curley," General Custer's Crow Indian Scout, by Edward Sawyer. The design was sculptured in bronze on a sterling silver plate. "Rattlesnake," Frederick Remington's famous creation, was also reproduced by George Washington Mint on sterling silver.

In 1973, Medallic Art Co. of Danbury, Conn., assumed responsibility for the programs begun by the George Washington Mint. The change-over was made easier by the fact that Medallic had been producing most of George Washington Mint's plates.

Medallic Art Co. is the oldest firm of its kind in America (over seventy-three years in existence). It is also considered the finest custom producer of high-relief medals in the country. During the past ten years the company has diversified its operations. Prior to diversification, 90 percent of Medallic's business was devoted to the execution of medals and related items for

George Washington Mint produced "Curly," Crow Indian by Edward Sawyer, a bronze sculpture on sterling in 1972.

A reproduction of a work
by Frederick Remington
inaugurated the American
Western Series by George
Washington Mint in 1972.

private and governmental organizations (domestic and foreign). Currently, over 60 percent of the company's production is devoted to collectibles.

Medallic notified dealers that many of the projects initiated by the George Washington Mint would be completed by the company. "The Rites of Spring," by Pablo Picasso, second in the Modern Masters Series, was issued in 1973 at $150. The eight-inch plate contained over six ounces of silver and the edition was limited to 9,800 individually numbered plates. Medallic continued the Mother's Day plate series started by George Washington Mint. The second plate featured a reproduction of "Motherhood," the 1899 rendering by Victor D. Brenner. The edition numbered 2,500 plates, and had an original issue price of $175. Each individually numbered plate contained over ten ounces of silver.

Jacques Lipschitz's "Salute to Israel," another project begun by the George Washington Mint, was also produced by Medallic Art. The plate commemorated the twenty-fifth anniversary of the founding of Israel.

George Washington Mint's first annual collector plate, introduced in 1972, was ''Whistler's Mother.''

Israel's twenty-fifth anniversary was commemorated in George Washington Mint's ''The Struggle'' by Jacques Lipschitz.

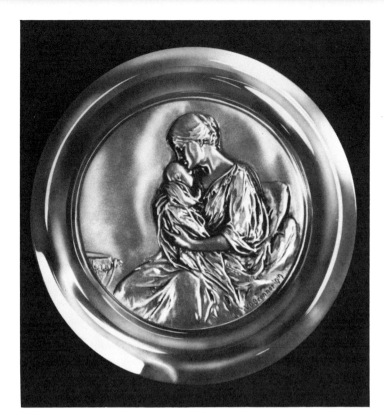

193

"Motherhood," created by
Victor D. Brenner in 1899,
was the subject of
Medallic Art's second
Mother's Day plate.

"The Arsenal of
Democracy" by N. C.
Wyeth was the first plate
in George Washington
Mint's Americana Series.

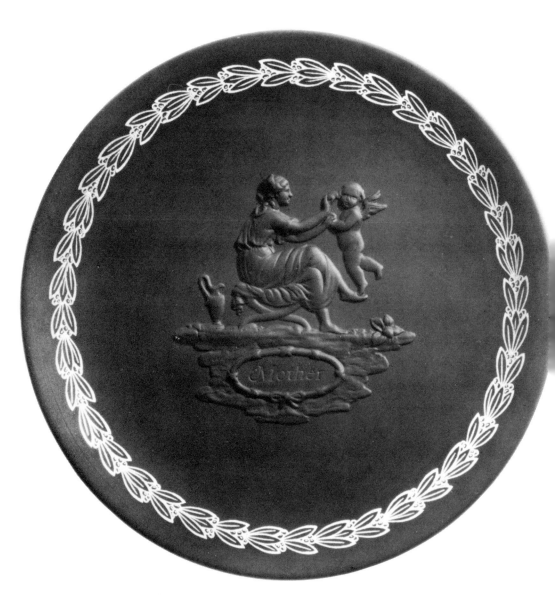

Wedgwood's first Mother's Day plate, introduced in 1971, was made in the world-famous pale blue jasper with hand ornamented white bas-reliefs. The plate has a border of white laurel leaves.

WEDGWOOD

Wedgwood, the world's largest producer of domestic earthenware, was in existence over two hundred years before it produced its first Christmas plate.

1969 marked the bicentenary of founding of the factory at Etruria, a village built by Josiah Wedgwood near Stoke-on-Trent, England. The company is famed for its jasperware. This unique ware was perfected by Josiah Wedgwood after years of research and over ten thousand experiments. Jasperware is known for its whiteness, density and transparency. Wedgwood colored in shades of blue and green has become so familiar that the terms Wedgwood blue and Wedgwood green are immediately understandable. Jasperware is also seen in black and other colors, and of course white is used in relief.

The Wedgwood Christmas plate is eight inches in diameter and is produced in blue and white jasper. The traditional border of holly leaves is hand-ornamented in white bas-relief. The mold for the 1969 plate was destroyed in a public ceremony. All molds for the plates are destroyed once production has been completed. The company does not reveal the number of plates in a given edition, but it is known that the 1969 issue was more limited than the 1970 and 1971 issues. The company further disclosed that issues produced subsequent to 1971 would be more limited.

In 1971 Wedgwood introduced its Mother's Day series. These plates are in either blue or green jasperware and measure between six and six and a half inches in diameter. The suggested retail price is approximately $20.00.

Another series produced by Wedgwood is the Queen's Ware children's plate. Queen's Ware, a china like earthenware, was named by permission of Queen Charlotte in 1765. The plates depict fairy tales by Hans Christian Andersen. "The Sandman," "The Tinder Box," and "The Emperor's New Clothes" were the first three tales chosen. The six-inch plates were initially priced for $6.95. However, the 1973 plate had a suggested retail price of $7.95.

In 1971 Wedgwood revived an old tradition by issuing the first in a series of annual calendar plates.

"Carousel," the 1972 calendar plate by Wedgwood, the second in the series.

The Wedgwood calendar plate series was begun in 1971. The plates are vastly different from the Christmas and Mother's Day plates. Jasperware is not used. The Queen's Ware calendar plates have mixed colors and intricate designs of a more contemporary styling. The twelve months and their zodiac signs are the theme. The first plate in the series retailed for $12.00, but the price has been increased slightly for the later editions.

In 1972 Wedgwood inaugurated an American Independence Series to commemorate the Bicentennial of the United States. The series consists of six plates:

Boston Tea Party (1971) Washington Crossing the Delaware (1974)
Paul Revere's Ride (1972) Battle at Yorktown (1975)
Battle of Concord (1973) Signing the Declaration (1976)

Each plate in the series is limited to an edition of 5,000 and is listed for about $30.00.

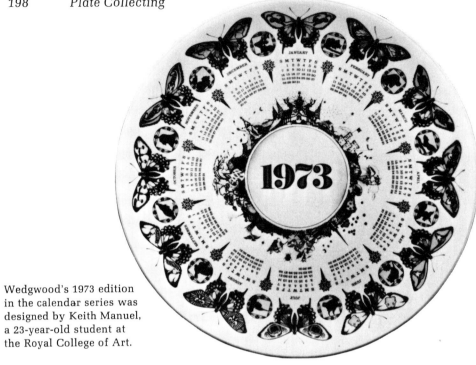

Wedgwood's 1973 edition
in the calendar series was
designed by Keith Manuel,
a 23-year-old student at
the Royal College of Art.

"The Sandman" by Hans Christian Andersen represents Wedgwood's first plate (1971)
in its Children's Story Plate Series.

Wedgwood's second issue (1972) in its Children's Stories for Young Collectors Series depicts the Hans Christian Andersen fairy tale "The Tinder Box."

The famous tale of "The Emperor's New Clothes" is the subject of the 1973 edition of Wedgwood's Children's Stories for Young Collectors Series.

Wedgwood's American
Independence Series
began in 1971 with the
issuance of "The Boston
Tea Party."

The 1974 calendar plate
is entitled "Camelot." The
characters of Camelot
form the border of the
plate, which also includes
the signs of the Zodiac.

The charming story of "The Ugly Duckling" was chosen for the fourth edition (1974) of Wedgwood's Children's Stories for Young Collectors.

Paul Revere's Ride (1972) is the subject of the second plate in Wedgwood American Independence Collection.

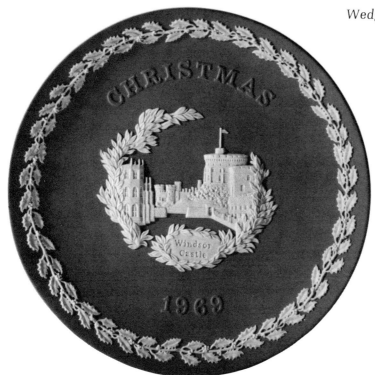

Wedgwood initiated its
Christmas plate series in
1969. The first plate
depicts Windsor Castle.

The 1973 edition of
Wedgwood's American
Independence Series
commemorates the Battle
of Concord.

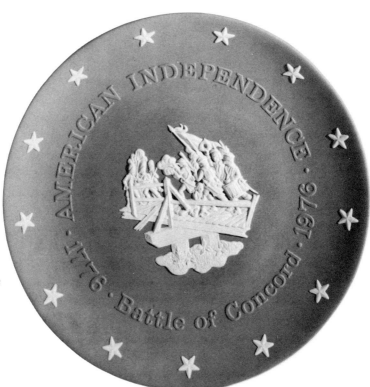

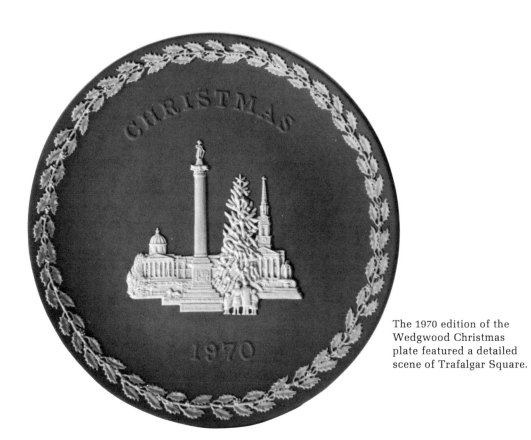

The 1970 edition of the
Wedgwood Christmas
plate featured a detailed
scene of Trafalgar Square.

London's famed Piccadilly
Circus with the statue of
Eros in the foreground is
the subject of Wedgwood's
1971 Christmas plate.

As in the previous Christmas plates produced by Wedgwood, the traditional holly is the border for the 1972 plate, which depicts St. Paul's Cathedral.

The Tower of London, rich in historical tradition, is the subject of Wedgwood's 1973 annual Christmas plate.

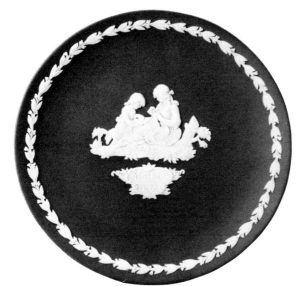

The 1972 Mother's Day plate utilized a design created for Wedgwood in 1795. Called "The Sewing Lesson," the plate is made in the Wedgwood green and white jasperware.

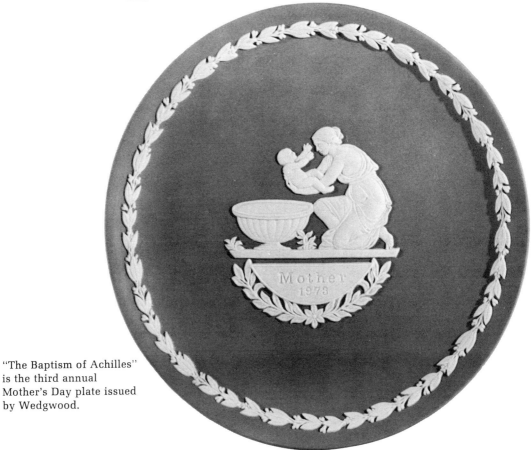

"The Baptism of Achilles" is the third annual Mother's Day plate issued by Wedgwood.

In 1972, Royal Worcester Porcelain Co., Inc. introduced the first of a series of twelve dessert plates by Dorothy Doughty. The first plate was entitled "Redstarts and Beech."

ROYAL WORCESTER

True to its tradition, Royal Worcester, the oldest manufacturer of porcelain in England (1751) chose to make its debut in the world of collector plates an auspicious one. In 1972 the company introduced a limited edition series of twelve dessert plates by Dorothy Doughty, the renowned porcelain artist.

Royal Worcester had been producing Dorothy Doughty's porcelain sculptures since 1935, the year the first pair of her American Bird Series was issued. The hand-painted bas-relief bird plates were introduced to the public at a major exhibit at Worcester House in London in 1961. Production of the plates was postponed until the American Bird series was completed. The American Bird Series was Miss Doughty's crowning achievement.

The series is to be issued at the rate of one subject a year for twelve years commencing with 1972. A pair of Redstarts graced the first plate which was issued in a limited edition of 2,000 and retailed for $125. Only 1,000 of the hand painted plates were available for distribution in the United States.

The second plate in the series featured the Myrtle Warbler. The size of the edition was increased to 3,000 plates and the price to $175. The plates remaining in the series are:

Blue-grey Gnatcatchers
Blackburnian Warbler and Western Hemlock

Blue-Winged Sinas and Bamboo
Paradise Wyday
Bluefits and Witch Hazel
Mountain Bluebird and Pine
Cerulean Warblers and Beech
Willow Warbler and Cranes Bill
Ruby-Crowned Ringlets and Abutilon
Bewick's Wren and Yellow Jasmine

Royal Worcester also introduced a series of pewter plates in 1972. The series is entitled "Birth of a Nation," and the five plates depict major events that led to the Declaration of Independence. This tribute to the Bicentennial of the United States will conclude in 1976. Each plate weighs forty ounces and the center is modeled in deep bas-relief rather than being merely etched or engraved. A specially designed commemorative back stamp appears on each plate. Production of each plate is limited to the year of its issue. The 1972 plate portrays the Boston Tea Party in Boston Harbor on December 16, 1773. The Ride of Paul Revere was the subject of the 1973 plate and the Incident at Concord was chosen for the 1974 issue.

All of the plates in the series were designed by Prescot Baston, a renowned sculptor and head of Sebastian Studio Inc., of Marblehead, Massachusetts. Mr. Baston is famed for his three-inch figurines which recreate in complete detail famous characters from history and literature. Mr. Baston was also selected to reproduce the Lincoln Memorial statue in Washington on the occasion of the 150th anniversary of Lincoln's birth.

The second plate in the Dorothy Doughty dessert plate series by Royal Worcester featured the Myrtle Warbler.

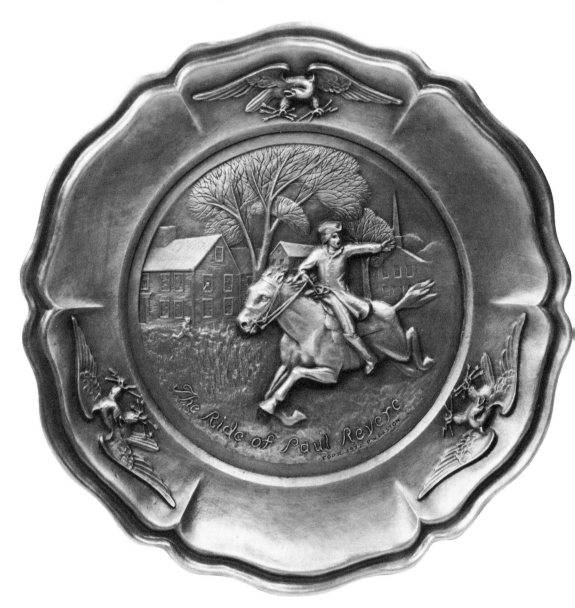

"The Ride of Paul Revere" was the title of the 1973 plate by Worcester Pewter.

The third plate in Worcester Pewter Bicentennial series was entitled
"Incident at Concord."

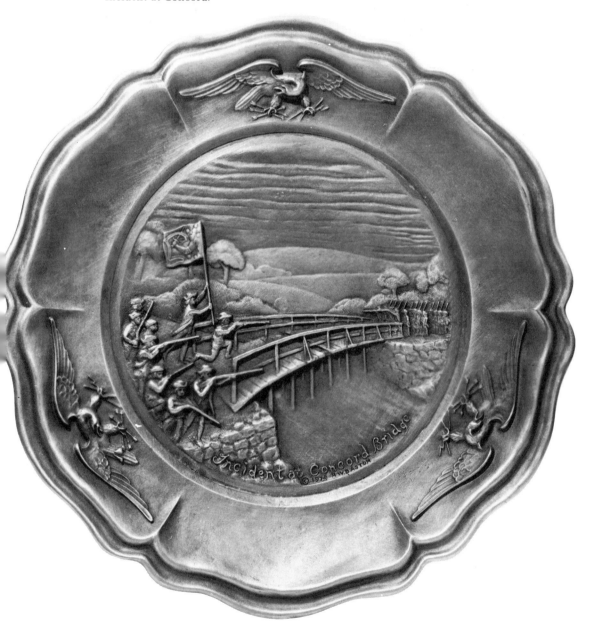

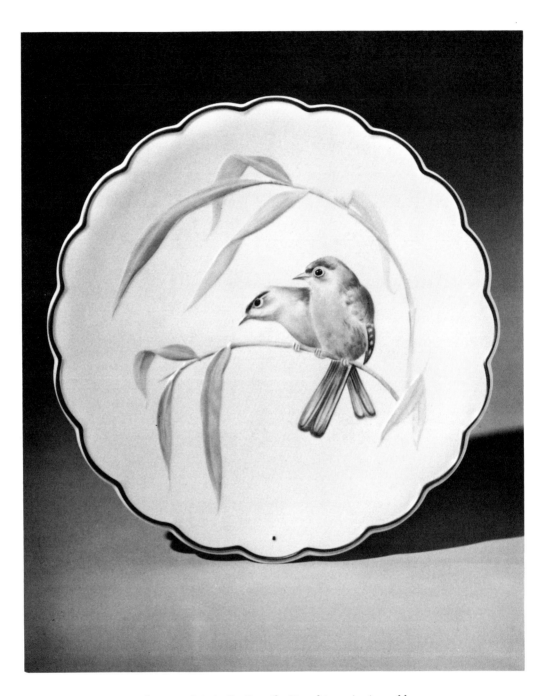

The 1976 plate in the Dorothy Doughty series issued by
Royal Worcester was "Blue Winged Sivas on Bamboo."

CRITERIA FOR
SELECTING PLATES

For the new collector, the plate market can be quite confusing, owing to the vast number of plates issued during recent years. Many new collectors are aware that they lack the knowledge required to make wise selections. They are understandably wary about building a collection without some guidelines. Probably the best suggestion for the new collector is to find a recommended dealer whom he trusts. The rapport between a reputable and knowledgeable dealer and a collector can be a rich and rewarding experience for both parties. In those instances where such a relationship is difficult, there are several fundamental guidelines to follow:

Artistic Value Reliability of Manufacturer
Restriction on Edition Technological Considerations

ARTISTIC VALUE

Except in rare instances, the value of most plates is not intrinsic. A solid gold plate, for example, is obviously valuable in itself. However, most plates are judged on their artistic qualities. The beauty and originality of the design are significant factors for the highly rated plates. The new collector should consider such questions as "Who created the design for the plate?" "Is it an original work of art?" "Is the artist considered to be a good one by recognized experts in the field?" The manufacturer's testimonial should be substantiated by objective standards.

215

Much of the success of Lenox's Boehm Bird plates and Franklin Mint's Christmas series by Rockwell may be attributed to the public recognition accorded the artists.

Of course, the presence of a name artist is not an absolute guarantee. The artistic value must be able to stand on its own merits. There have been artistic failures by recognized geniuses for a variety of reasons. The design may not have been appropriate for the medium, or the artistic concept was too complex.

But after all these factors have been considered, the ultimate judgment rests with the collector himself. The plate must please his sense of beauty.

A plate's visual beauty is its most important characteristic. Since most plates serve no function other than decorative, they must evoke a positive emotional response. Collectors often prefer to pass up fantastic profits rather than surrender an object which provides them with this sense of beauty. Objects of art are frequently scarce for this reason.

RESTRICTIONS ON EDITION

A plate's investment potential is frequently influenced by the size of its edition. A plate which has been acclaimed for its beauty is often in great demand. If the number of plates produced is not enough to meet the demand, the secondary market price will rise accordingly. The price will continue to remain high if enough collectors refuse to sell.

However, it is impossible to set an arbitrary figure to guarantee a successful issue. The enormously successful Bird of Peace Plate issued by the Boehm Studio had a limited edition of 5,000. There have been editions of similar size which were dismal failures. Sometimes, as in the case of the Peace Plate, the availability of the plate is more apparent than real. The announced edition size of 5,000 included almost a thousand plates earmarked for the White House and embassies. The public was left to compete for the remaining four thousand.

The distribution network of the manufacturer can have a major impact. Though Lenox does not disclose the size of editions, it is reported that approximately 35,000 copies of the Boehm Bird Plates are issued annually. The series has been quite popular with collectors. The Lenox name, Boehm's reputation, and the beauty of the plates played significant roles in the series' success. However, there were two unique factors at play in this particular case. Lenox has a network of 4,000 dealers which employ the most sophisticated of merchandising techniques. Consequently, thousands of people who probably would never have been exposed to the plate were given the opportunity. Furthermore, the enthusiasm of the Boehm collector is well known. Many ardent collectors of Boehm porcelains responded to the Lenox series.

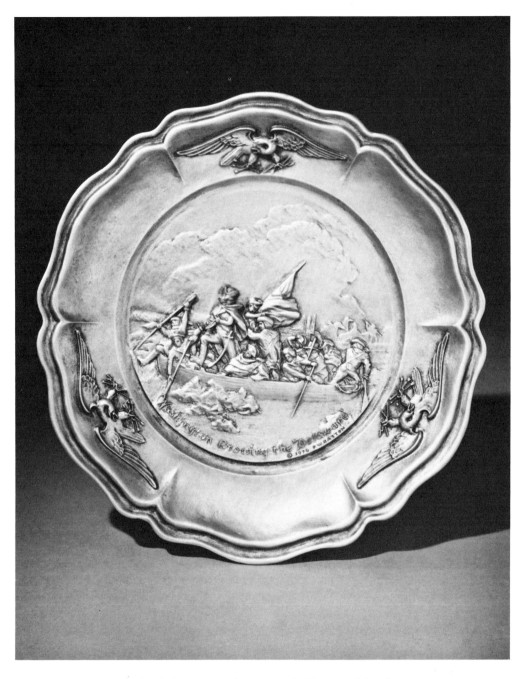

The final plate in Royal Worcester's Bicentennial series
depicts Washington crossing the Delaware.

But, generally, the more limited the edition, the greater the investment potential. However, the manner in which the edition has been limited is quite significant. An edition with a pre-announced limit is considered to be more valuable than editions restricted by a calendar date.

To many experts in the field, the edition is meaningless unless the plates are individually numbered. A simple announcement or an accompanying certificate fail to meet the standards of a true limited edition.

RELIABILITY OF MANUFACTURERS

The name of the manufacturer is often the major determinant in a plate's success. The firm's reputation for skilled craftsmanship, reliability and integrity should be a significant factor in the decision-making process.

There is little doubt that the Wedgwood name contributed greatly to the success of the company's first plate in 1969. Collectors knew of the company's reputation for excellence.

There are many pitfalls in purchasing a plate made by a new firm. Not only is there no track record of performance, but also there is less certainty that the issue will be completed. A producer in precarious financial straits frequently must discontinue operations, and the unwitting collector loses out. He is left without the issues needed to complete the series.

An established firm is less likely to cut corners or risk damage to its reputation. In the unnumbered editions, the collector must trust the integrity of the producer.

Furthermore, there is usually more artistic and technological expertise available to large, established companies. They are able to afford the skilled craftsmen and the time required to produce a valuable plate. A small company would find it difficult to undertake the Ulysses S. Grant Commemorative by Haviland. Twenty-three shades are represented in the design, and forty-six days are needed to proof the plate.

TECHNOLOGICAL CONSIDERATIONS

In the early stages of plate collecting, technological considerations were relatively insignificant. Almost all the plates were porcelain. The secrets to producing good porcelain had been known for centuries, and there were few innovations. However, the competition for the collector's attention grew intense, and the pace toward more sophisticated technology turned brisk.

Production techniques were refined with an emphasis on intricate detail. New materials were tested.

At the same time manufacturers began trying other materials, they also

began considering how to broaden the sensual appeal of their art form. For centuries plates had been pleasing "eye" objects, strictly two-dimensional. As more intricate production techniques were achieved, designers began to create some plates that would please the sense of touch. Today, some plates are tactile, three-dimensional sculpture—art objects not only to be looked at, but also to be touched.

These innovations enhanced the value of many plates. For the new collector, however, the technology is not as important in the selection process as are the other three factors. However, as he becomes more experienced and more knowledgable, the new collector will rely on technology and it will have a greater influence in his decisions.

The 1976 edition of Haviland's Twelve Days of Christmas
is entitled "Seven Swans a-Swimming."

BOOKS AND MAGAZINES ON PLATE COLLECTING

There are several publications which can prove helpful to the serious plate collectors. *The Plate Collector* is a monthly magazine devoted almost exclusively to plates. It is a valuable source of information on new issues and the status of the market. A three-year subscription costs $13, two years $9, one year $5. It may be ordered by writing:

> *The Plate Collector*
> Box 1041—P.C.
> Hermit, Texas 79745

Three magazines published in Dubuque, Iowa, are helpful to the plate collector. *The Antiques Journal* frequently features articles pertaining to collector plates. It also offers an extensive classified section for the collector who wishes to buy or sell a particular plate. A yearly subscription costs $6. *The Antique Trader*, a weekly tabloid, is considered the Bible to the trade. Its yearly rate is $8. *The Antique Trader Price Guide to Antiques and Collector's Items* is a quarterly publication which gives market prices of various plates. The price for the quarterly is $4. All three publications are available by writing to:

> *The Antique Trader*
> P.O. Box 1050
> Dubuque, Iowa 52001

Acquire magazine, as its name implies, is devoted to the contemporary collectibles market. It is a beautifully illustrated magazine which has featured several articles on plates. It is published five times a year and may be ordered by writing:

> Acquire Publishing Co., Inc.
> 170 Fifth Avenue
> New York, New York 10010

The collector who wishes to gain a wide knowledge of the field should consult his local librarian and the *Periodic Guide to Literature*. The fantastic surge in popularity experienced by collecting in recent years spawned scores of articles in national magazines such as *Forbes*, *Fortune*, etc.

There are several books on plates which could prove helpful to the new collector. *The Wonderful World of Plates* by Louise Schaub Witt may be obtained by writing to the author at Box 38, Shawnee Mission, Kansas 66201. *Plates from the Royal Copenhagen Manufactory* and *The Story of Bing and Grøndahl Christmas Plates* by Pat Owen are available through dealers and local gift shops.

Finally, the International Plate Association publishes a newsletter which provides the collector with an abundance of information on the field. To join the Association, send $10 to

> Internation Plate Association
> c/o Mrs. Louise S. Witt
> Box 38
> Shawnee Mission, Kansas 66201

"The Unicorn in Captivity" was the first offering in a series of six plates introduced by Robert Haviland & C. Parlon in 1971.

The 1972 edition of Robert Haviland & C. Parlon's Limoges porcelain plates was entitled "The Start of the Hunt."

The Declaration of Independence is the subject of the final
plate in Haviland's Bicentennial series.

GUIDELINES FOR ORGANIZING
A COLLECTORS' PLATE CLUB

1. *Enlist the aid of a local dealer.* A local dealer is the ideal source for obtaining names of potential members. He will undoubtedly cooperate in the endeavor, since a club will enhance his business. An enthusiastic and thriving club creates publicity, interest, and new customers for him.

2. *Select a permanent location for the meetings.* The meeting place should be big enough to accommodate a minimum of fifteen people comfortably. It should be in a convenient location. The local library frequently offers meeting rooms for organizations such as this.

3. *Publicize the first meeting.* Once the founding member or members have obtained a location and a skeleton list of potential members, the next step is to publicize the first meeting. The local "shopper" welcomes news items of this type. Church bulletins, posters, and flyers are also good vehicles for promoting the event. Personal invitations should be extended to known collectors.

4. *Plan a detailed program for the first meeting.* The first meeting of any club or organization is frequently its most important. A good start is crucial. The meeting must be organized to insure there will be sufficient interest and enthusiasm to warrant another. Schedule elections of officers. Offer a tentative schedule of programs and events. Announce the purpose of the club. Have an interesting speaker on hand to talk

225

about a specific area of the hobby. Appoint various committees such as publicity, membership, program, etc. Announce the date and place of the next meeting. Vote on dues. Discuss various publications and national organizations available to the plate collector.

5. *Follow up.* Until the officers are elected and committees are in operation, the club will require nurturing by the founders. Maintain contact with the collectors who attended the first meeting. Continue the publicity and promotion to enlist more members. Adhere to the scheduling for the second meeting.

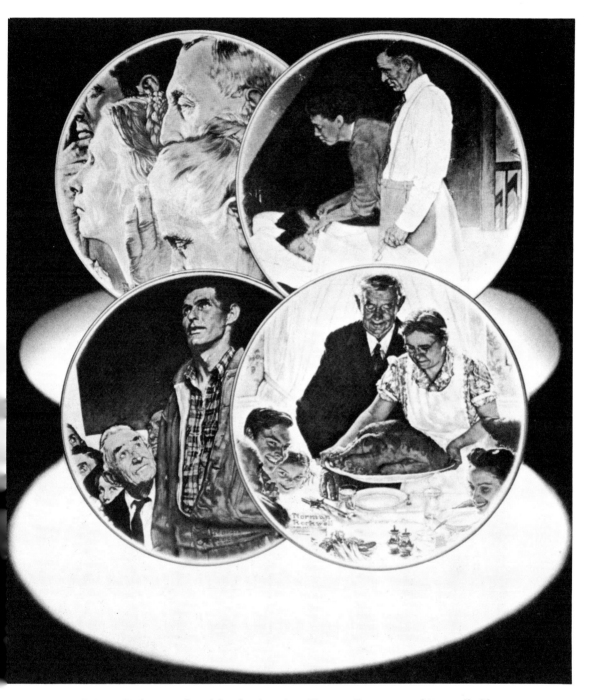

In 1976 Gorham produced for the American Express Company and its cardholders a series of four plates entitled "Four Freedoms Collectors Plates." Inspired by four paintings done by Norman Rockwell for *The Saturday Evening Post* in 1943, the plates depict Freedom of Speech, Freedom of Worship, Freedom from Want and Freedom from Fear.

In 1975 Franklin Mint issued a new series, The Four Seasons. These were Champlevé plates, which combine sterling silver with multicolored enamels. "Spring Blossoms" was one of the four.

GLOSSARY OF
PLATE COLLECTING TERMS

Annual: An item issued once each year as part of a series.

Backstamp: The name stamp or signature of a manufacturer which usually appears on the underside of the ware. Can be stamped, decal applied or incised into the clay.

Basalt: Unglazed black stoneware.

Bisque: A white, marble-like, unglazed hard porcelain, usually fired twice. Used particularly in producing figurines and other intricately detailed designs.

Bone China: China that contains a percentage of bone ash or its commercial equivalent in addition to refined clays, giving it a characteristic whiteness, strength and, if thin, translucence.

Ceramic: Any product which is made partly or wholly with clay. This includes everything from the finest porcelain to the commonest pottery.

China: A ceramic made of white clay and pulverized stone, fired at high temperatures. It is thin, translucent, resistant to chipping and cracking. It will also ring clearly when tapped. It is another name for porcelain.

Closed Edition: A closed edition may be either limited or non-limited. The limited edition is closed when the predetermined number of plates has

229

been made. In a non-limited edition, the edition becomes closed when production closes. This decision in a non-limited edition may be based on several factors.

Cobalt Blue: The most common form of underglaze coloration. The extremely high temperature required to glaze a piece of porcelain will destroy most of the colors used on underglazed pottery. Cobalt, however, withstands the heat very well and can be used to produce a wide range of blue shades.

Commemorative: An item made to honor someone or celebrate an event or place.

Crystal: Fine glass which is given extra weight, better refractive qualities, and a clear ringing tone by the addition of lead. When the proportion of lead reaches 24%, it is called "full lead" crystal.

Embossed: A raised or molded decoration either produced in the mold or formed separately and applied to the body of a piece before firing.

Glaze: The liquid glass-like substance used to cover and seal a piece of porcelain after the first firing and before the second high-temperature firing. It is used for decorative purposes and to make the surface non-absorbent and more resistant to wear.

Jasperware: A hard stoneware requiring no glaze. Although developed by Wedgwood and best known in the classic cameo blue and white, it is also produced in other colors and by other companies.

Limited Edition: An edition of a contemporary product, in which the total number of the edition is announced at the time production is commenced.

Mint Condition: The term "mint condition" originated in the coin world. It referred to a coin that was fresh from the minting process, uncirculated and untouched by human hands. For a plate to be labeled "mint condition" it must be in the same condition in which it came from the factory.

Mold: The form into which a substance is poured to attain a certain shape. In ceramic work, the mold is usually made of gypsum or plaster of Paris, which absorbs water while remaining firm. Once the mold for a particular plate is lost or destroyed, that item can never be exactly duplicated.

Non-Limited Edition: An edition in which no total number is announced. It may be produced in perpetuity or may be closed at any time at the will of the producer.

Open Edition: Refers to a limited edition still being produced, although it may be completely sold out.

Overglaze: Design applied to clayware after it has been fired and glazed. Because they are not subjected to high temperatures, the colors in this decoration tend to be more vivid than in underglaze decoration.

Porcelain: A fine, white, translucent, hard vitreous ware with a transparent glaze. One test for porcelain is to hold it up to the light and place your hand or a pencil behind it. Usually a shadow can be seen through the object.

Pottery: Clayware which lacks the hardness, translucency and whiteness of porcelain. It is more common than porcelain and easier to work with.

Relief: A design or figure which is raised to stand out from the surface of its background. In *low relief*, the design is raised enough to be felt and to emphasize its shapes; in *high* or *deep* relief it stands out far enough to create a three-dimensional effect. *Bas-relief* is commonly used to mean slightly deeper than low relief.

Secondary Market: Is a term referring to any transactions which take place after the original issue.

Secondary Market Price: The price a plate commands on the market. For a plate in great demand the secondary market price will climb while the plate is still being delivered at original issue price.

Seconds: Articles judged by the manufacturer or distributor to be of a grade below quality. (Sometimes called "second sorting.") This is usually indicated with a scratch or gouge through the glaze over the trademark.

Sterling: The standard of purity for precious metals. The exact requirement for sterling silver varies among countries; in the U.S. it must be 92.5% pure.

Underglaze: A term referring to a painting or mark applied under the glaze on once-fired porcelain before the glazing and second firing. As explained above, cobalt blue is one of the few colors that can withstand the high temperature of the second firing.

The first offering of the Franklin Mint Porcelain division depicted
the flowers of the year, as in this plate for November.

NAMES AND
ADDRESS OF COMPANIES

American Historical Plates Ltd.
Van Son Building
Union and Liberty Street
Mineola, New York 11501

Bing and Grondahl
111 North Lawn Avenue
Elmsford, New York 10523

Edward Marshall Boehm Studio
25 Fairfax Street
Trenton, New Jersey 08638

Fenton Art Glass Co.
Williamstown, West Virginia 26187

Franklin Mint
Franklin Center, Pennsylvania
14063

Gorham Co.
Providence, Rhode Island 02907

Haviland and Co., Inc.
11 E. 26th Street
New York, New York 10010

Haviland and Parlon
c/o Jacques Jugeat, Inc.
225 Fifth Avenue
New York, New York 10010

Intercontinental Fine Arts Ltd.
555 West Adams
Chicago, Illinois 60606

Kay Mallek
208 North Alvernon Way
Tucson, Arizona 85712

Lalique
c/o Jacques Jugeat, Inc.
225 Fifth Avenue
New York, New York 10010

Lenox China
Prince and Mead Streets
Trenton, New Jersey 08605

Lincoln Mint
1 South Wacker Drive
Chicago, Illinois 60606

Medallic Art Co.
Old Ridgebury Road
Danbury, Connecticut 06810

Pickard
P.O. Box 309
Antioch, Illinois 60002

Porsgrund
Norwegian Silver Corp.
Mr. A. Abrahamsen
114 E. 57th Street
New York, New York 10022

Reco International Corp.
 (Royale, Fürstenberg, Royal,
 King's Porcelain Factory,
 Marmot)
26 South Street
Port Washington, New York 11050

Rosenthal U.S.A. Ltd.
411 E. 76th Street
New York, New York 10021

Royal Copenhagen
Gura Public Relations
30 E. 60th Street
New York, New York 10022

Royal Doulton, Inc.
400 Paterson Plank Road
Carlstadt, New Jersey 07072

Royal Worcester
11 E. 26th Street
New York, New York 10010

Schmid Bros. Hummel
55 Pacella Park Drive
Randolph, Mass. 02368

Svend Jensen
1010 Boston Post Road
Rye, New York 10580

Wedgwood
555 Madison Avenue
New York, New York 10022

GENERAL INDEX

Hetreau, Remy, *123, 124, 125, 126*
Honey gold, *157*
Houser, John, *153*
Hummel, Berta, *179*
Hummel, Franz, *179*
Hummel, Victoria, *179*
Hutschenreuther, *183*

I

Innocentia, Sister (Berta Hummel),
 179
International Plate Association, *18,
 20, 26, 33, 222*

J

Jensen, Georg, *10*
Jensen, Oluf, *64*
Jensen, Svend, *14, 129-133*
Jermiassen, Joban, *163*
Jubilee plates, *50*
Junghust, Peter H., *20*

K

Kemlin, *173*

L

Lalique, *6, 135-139*
Lalique, Marie Claude, *136*
Lalique, René, *135*
Latticinio (technique), *3*
Lebrevre, *173*
Lefkowitz, Louis, *22*
Lenox, *10, 14, 61, 141-145, 216*
Lenox-Boehm plates, *144*
Lenox, Walter Scott, *141*
Limoges, *115*
Limosin, Leonard, *147*
Lincoln Mint, *14, 17*
Lincoln, Abraham, *18*
Lincoln, Mary Todd, *18*
Lindencrone, Effee Hegermann, *51*

Lipschitz, Jacques, *191*
Lissar, M., *119*
Lockart, James, *14, 158*
Loup, Jean Paul/Betourne, *147-151*

M

Mallek, Kay, Studio, *153-155*
Mao-Tse-tung, *10*
Medallic Art Company, *17, 190-193*
Mervis, Keith, *8, 9, 10*
Mother's Day plates,
 Jean Paul Loup/Betourne, *148*
 Bing and Grøndahl, *10, 16, 50*
 Fenton Art Glass, *76, 78*
 Franklin Mint, *86*
 Fürstenberg, *101*
 George Washington Mint, *191*
 Gorham, *108*
 Haviland, *124, 125, 126*
 Svend Jensen, *129*
 Medallic Art Co., *191*
 Porgsgrund, *164*
 Wedgwood, *196*
Myerson, Bess, *26*

N

New York City Department of Con-
 sumer Affairs, *22*
Nixon, President Richard M., *10*
Nulsen, Kis, *51*

O

Owen, Pat, *222*

P

Palley, Reese, *14, 18, 58, 189*
Paris Plate, *2*
Petitfils (jeweller), *135*
Phillips, Gordon, *88*
Picasso, Pablo, *189, 192*
Pickard, *14, 157-161*

INDEX TO ILLUSTRATIONS